HAND TO EYE
CONTEMPORARY ILLUSTRATION

HAND TO EYE

CONTEMPORARY ILLUSTRATION

EDITED BY ANGUS HYLAND AND ROANNE BELL

LAURENCE KING PUBLISHING

CONTENTS

INTRODUCTION

The age-old discipline of illustration, or commercial art as some may prefer to call it today, has enjoyed something of a renaissance in recent years. For a discipline that was in a state of crisis and almost on the verge of extinction for the best part of the 1990s, this was a timely resurgence.

Newly developed and ever more affordable software such as Photoshop, Freehand and Illustrator, combined with the fact that hardware was now cheaper and faster than ever before, gave trained illustrators a wonderful digital playground in which to develop new and exciting approaches. Vector illustration was born, and what seemed like a new stylistic movement of minimal slickness and highly polished clean lines followed. Illustration rose in popularity and was seen in all types of visual communication, from editorial and print design through to fashion publicity, advertising, music graphics and web design. Many major brands and music artists have used illustration in their promotional campaigns. Illustrator Jamie Hewlett's collaboration with Damon Albarn, frontman of cult British band Blur, shows the powerful potential of illustration. They took the medium to another level in creating Gorillaz, an internationally successful rock band whose members are 2-D characters that originated on Hewlett's drawing board.

As is often the case with emergent technologies, however, the innovations that facilitate creativity can also stifle or restrict it. While traditionally trained illustrators created truly innovative work with these new techniques, art directors, art editors and designers the world over realized they could all but eliminate creative outsourcing from their budgets by simply creating their own work, aided by the point-and-click simplicity of ever-evolving graphics packages.

Inevitably, plagiarism and a glut of "cookie cutter" work, drawing heavily on the talent and unique styles of the pioneers of digital illustration, followed. Perhaps it was equally inevitable that the bulk of such output would prove homogenized and soulless. It is no surprise to hear of illustrators having work of a lesser standard to their own falsely attributed to them, such is the ease with which a once unique illustrative style can now be cloned. But while copying a style is easy with the tools at hand today, aesthetics are not all-important in communication art: idea and content have equal bearing on the success of an illustration. The distinction between a graphic designer and an illustrator is defined by their unique skills in these fields; the fact that both camps frequently employ the same technology does not necessarily mean that their areas of expertise are interchangeable.

Not all graphic designers who turn their hand to image-making deserve to be vilified, however. Many can rightfully claim the title of designer/illustrator, a phenomenon that will grow as the boundaries between the communication arts continue to blur. A designer who understands the difference in roles of both disciplines, and is able to approach the two from different stances is in a position to illustrate successfully. Examples of such creatives featured in this book include Delta, Frauke Stegmann, Kenji Cho, Laurent Fétis, Lizzie Finn, Matt Duckett, Patrick Thomas, Rinzen and Seb Jarnot.

Naturally, as clients anxious to keep up with current trends demanded more digital illustration, the number of digital artists rose. The market soon became overloaded with under-qualified creatives and mediocre imagery, and what had been a new and exciting look quickly became tired and forced. Scottish illustrator Bernie Reid comments:

I THINK WE ARE ALMOST AT SATURATION POINT SO I RECKON THERE WILL BE A SLIGHT DECLINE IN THE USE OF ILLUSTRATION BUT THIS WILL PROBABLY BE A GOOD THING IN THE SENSE THAT IT WILL WEED OUT ALL THE "FAKE-ASS" ILLUSTRATORS. I DON'T WANT TO SOUND TOO "DARWINESQUE" (OR COCKY) BUT I DO FEEL THERE IS A LOT OF RUBBISH OUT THERE AND IT DILUTES THE POOL.

This is an attitude that seems to prevail among many of this book's featured artists. Hungarian illustrator David Foldvari, explains:

WITH DIGITAL ILLUSTRATION, IT SEEMS THAT A CERTAIN STYLE BECOMES FASHIONABLE, EVERYONE JUMPS ON IT AND LEARNS THE TECHNIQUE AND IT BECOMES VERY BORING VERY QUICKLY. THERE ARE LOADS OF PEOPLE WHO KNOW HOW TO USE PHOTOSHOP AND ILLUSTRATOR BUT THAT'S NOT ENOUGH TO PRODUCE GOOD WORK. IT'S THE SAME AS MUSIC: KNOWING HOW TO PLAY A PIANO DOESN'T NECESSARILY MAKE YOU A GOOD MUSICIAN.

This last point echoes the words of Darrel Rees of London-based illustration agency, Heart, founded in the mid-1990s. At a seminar held by the Association of Illustrators in 2000 entitled "The Future of Illustration", Rees proposed:

THE COMPUTER AS A TOOL IS FREQUENTLY USED IN THE SAME WAY BY MANY PEOPLE. THE FILTERS, DISTORTIONS AND GENERAL MAGIC WORKED BY SUCH PROGRAMMES AS PHOTOSHOP ARE EASY TO APPLY AND ARE ACCORDINGLY OVERUSED... THE COMPUTER IN MANY WAYS HAS DEMOCRATIZED IMAGE-MAKING, BUT IT IS STILL VERY EASY TO USE BADLY. FOR THOSE WHOSE CRAFT IS PICTURE MAKING, GETTING INVOLVED WITH THE COMPUTER IN THIS WAY NEEDS TO BE DONE WITH RESEARCH, EXPERIMENTATION AND INGENUITY, WHICH THE DILETTANTE CANNOT MATCH.

Despite these woes, contemporary illustration still boasts an abundance of diverse talent and innovation. Mercifully, there has been a sustained reaction against the torrent of digital sameness in the form of a return to a lo-fi, hand-crafted aesthetic, a logical reaction to all the slick, vector-based work. Laura Lees, whose artwork combines tapestry and embroidery, is optimistic about this trend:

"HAND-CRAFTED" UP UNTIL QUITE RECENTLY SEEMED TO BE A DIRTY WORD. I AM DELIGHTED TO SEE ITS RESURGENCE AND TO SEE IT BEING USED IN A FAR MORE EXCITING WAY THAN EVER BEFORE.

And even if this return is not absolute, it is without question a phenomenon of considerable value to the discipline. Michelle Thompson, who uses a camera, letterpress, scanner and computer when creating her illustrations, observes:

I DON'T THINK DESIGNERS ARE COMMISSIONING HAND-CRAFTED ILLUSTRATION OVER DIGITAL WORK; I THINK THERE'S ROOM FOR BOTH. I'M SURE A LOT OF IMAGE-MAKERS LIKE ME HAVE FOUND BENEFITS TO USING DIGITAL TECHNIQUES WITHIN THEIR HAND-CRAFTED WORK.

Design writer Rick Poynor was already interested in this issue some four years ago. In an article entitled "Illustrate This" for *Frieze* magazine's November/December 1999 issue, he concluded:

WHAT WE ARE SEEING NOW, ILLUSTRATION'S CHAMPIONS SUGGEST, IS THE PERHAPS INEVITABLE SWING OF THE PENDULUM BACK IN THE OTHER DIRECTION. THE KEYBOARD-GENERATED LOOK HAS BECOME PREDICTABLE AND TRITE.

He speaks too of a detailed research paper, written by Rob Mason, a leading figure in the 1970s generation of self-styled "radical illustrators",

on the state of the discipline (which he says is a departure in itself, illustration being "woefully under-researched"):

IT'S ONLY NOW, SUGGESTS MASON, THAT SOME OF THE FINEST ILLUSTRATORS ARE DISCOVERING HOW TO RECONCILE THE COMPUTER WITH THEIR ESTABLISHED STYLES AND THEMES.

Much of the work featured in this book exhibits a return to traditional methods. Sometimes even entirely hand-crafted, the illustrations here incorporate time-honoured techniques as diverse as pen, pencil, acrylic, oils, canvas, wood, embroidery and collage. Peter Arkle, whose tools include pen, glue, acrylic, watercolour paints and, since last year, a computer, comments:

I THINK NOW, AS THE HAND-MADE HAS BECOME THE EXCEPTION, AND BECAUSE ANYONE CAN DABBLE IN GRAPHIC DESIGN OR ILLUSTRATION, THERE IS – OR AT LEAST THERE SHOULD BE – A GROWING INTEREST IN WORK THAT SHOWS A HUMAN TOUCH. WHEN SOMETHING HAND-DONE IS DROPPED IN AMONG PERFECTLY STRAIGHT LINES AND PERFECTLY HIGH-TECH TYPE, IT REALLY STANDS OUT.

Of course trends are cyclical, and what is new today will soon become old. Certainly there is still a place for the simplicity and cleanness of the vector image and indeed for photorealistic artwork. What we are now starting to see, and will hopefully continue to witness, is the happy co-existence of the hand-crafted and the digital. Some of the illustrators featured employ both styles: the Australian collective Rinzen and the UK-based agency Airside, for example, create both hand-crafted and vector artwork, depending on a project's brief.

The boundaries that traditionally separated classically trained illustrators from their digitally conversant counterparts continue to blur. Every contributor to this book was asked for their thoughts on the future of illustration as a discipline. French–Chinese image-maker Chiu Kwong Man, who works with charcoal, patterned paper and a computer, replied with this insight:

THE BOUNDARIES BETWEEN ILLUSTRATION AND ALL OF THE OTHER DISCIPLINES WHICH FALL UNDER VISUAL COMMUNICATION ARE BECOMING LESS DEFINED. IT'S AS THOUGH IMAGE-MAKING SEEMS A MORE APPROPRIATE DISCIPLINE TO HAVE, WHEREBY DIGITAL AND TRADITIONAL IMAGE-MAKING BECOME SUB-DISCIPLINES.

Lizzie Finn, whose work encompasses illustration, graphic design, art direction and moving-image design, comments:

I HOPE THAT ALTHOUGH THERE HAS BEEN A RECENT FASHION FOR USING ILLUSTRATION IN DESIGN, IT WILL CONTINUE TO BE USED AND PUSHED IN NEW DIRECTIONS. I THINK IT WILL BE LESS OF A SEPARATE DISCIPLINE. THE LINES BETWEEN ILLUSTRATION AND GRAPHIC DESIGN WILL CROSS OVER AND BECOME BLURRED, MAKING IT EVEN MORE DIFFICULT TO DECIDE WHAT TO CALL IT.

Including a range of work, both experimental projects and commissioned artwork, *Hand To Eye* aims to show how illustration can be rejuvenated by a reaction to digital dominance, even if that reaction is not an outright dismissal. Both established illustrators, including Andrzej Klimowski, Aude Van Ryn and Lucinda Rogers, as well as emergent practitioners, some graduating as recently as 2002, are featured here. Many images in the book show how tradition and technology can co-exist as much as contradict each other. Ultimately, for everybody featured, it is the idea behind a piece of work that is paramount. Richard Beacham, who uses acrylics and pencil to create his illustrations, before adding the final touches on a computer, comments:

DESKTOP-DEPENDENT WORK WILL ALWAYS HOLD ATTRACTIONS – THE SPEED AT WHICH AN ALREADY RENDERED IMAGE CAN BE MANIPULATED AND ALTERED USUALLY BEING THE MOST OBVIOUS PRO. IT'S JUST WHEN THE ILLUSTRATOR RELIES TOO HEAVILY ON THE COMPUTER ITSELF TO MANUFACTURE WORK THAT THINGS CAN GET AWKWARD. AS LONG AS THE IDEAS ARE THERE TO START WITH, THE IMAGE SHOULDN'T SUFFER, HOWEVER YOU MAKE IT HAPPEN.

The contributors featured in *Hand To Eye* demonstrate that digital technology will never replace the skill of traditional illustration; that the craft of image-making cannot be made redundant by technological advances. It is the responsibility not only of those who commission commercial art but also of every illustrator to ensure that the discipline continues to evolve and grow. In the words of Toronto-based illustrator Gary Taxali:

IT IS IMPORTANT THAT WE AS AN INDUSTRY REALIZE IT IS OUR POSITIVE EFFORTS THAT MAKE OUR CRAFT SEXY. THAT IS, STRIVING TO CREATE INTELLIGENT, ORIGINAL WORK IS OUR RESPONSIBILITY, AND THEN THE MARKET RESPONDS ACCORDINGLY. WE CREATE THE RENAISSANCE OF ILLUSTRATION.

CHRISTINE BERRIE

"COMPUTERS HAVE ENABLED US TO EXPLORE NEW PROCESSES AND NEW WAYS OF MAKING PICTURES," COMMENTS SCOTTISH IMAGE-MAKER CHRISTINE BERRIE. "BUT I THINK THE MOST INTERESTING WORK ORIGINATES FROM HAND-CRAFTED IMAGERY. IT IS REFRESHING, AT THE MOMENT, TO SEE MORE HAND-CRAFTED IMAGES. I HOPE THIS WILL ALWAYS BE THE CASE." HAVING GAINED A BACHELOR OF ARTS DEGREE IN VISUAL COMMUNICATION FROM GLASGOW SCHOOL OF ART, BERRIE WENT ON TO ATTEND THE ROYAL COLLEGE OF ART IN LONDON, GRADUATING WITH A MASTER OF ARTS IN COMMUNICATIONS IN 2002. SHE HAS COMPLETED VARIOUS PRIVATE COMMISSIONS AND IS NOW LOOKING FOR COMMERCIAL PROJECTS AS WELL. INSPIRED BY LONDON UNDERGROUND AND RAILWAY STATIONS AND "GOOD BOOKS, GOOD SONGS AND GOOD FILMS", BERRIE HOPES TO TRAVEL AND BUILD A BODY OF WORK REFLECTING AS MANY DIFFERENT PLACES AND CULTURES AS POSSIBLE.

BELOW/LEFT/BARONS COURT TUBE STATION, W14 BELOW/RIGHT/SE1
OPPOSITE/SOHO SQUARE

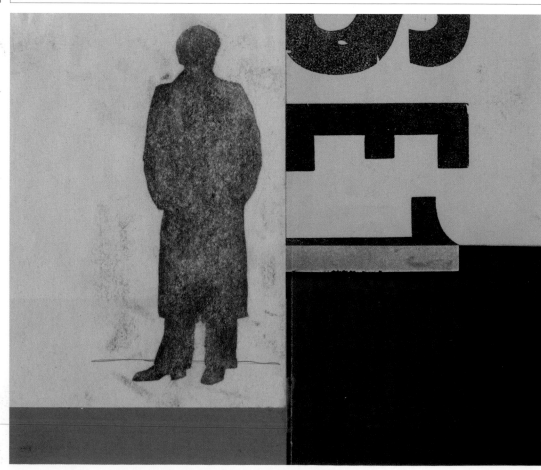

SOHO
SQUARE W1
CITY OF WESTMINSTER

CHRISTINE BERRIE

BELOW/LEFT & RIGHT/DARWIN BUILDING, RCA, SW7
OPPOSITE/LEFT/DARWIN BUILDING, RCA, SW7
OPPOSITE/RIGHT/STAMFORD BROOK TUBE STATION, W6

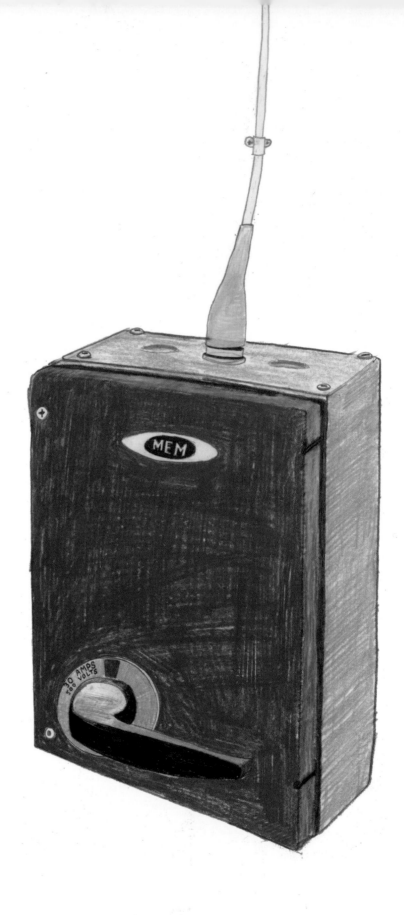

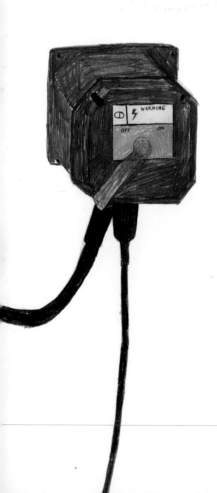

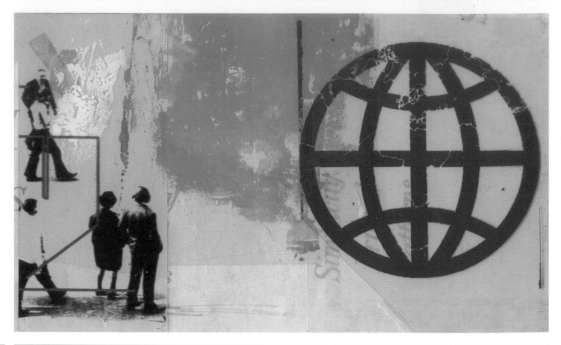

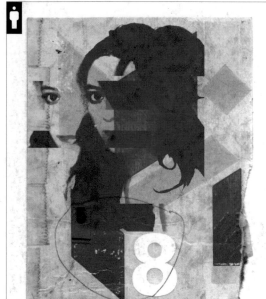

MICHELLE THOMPSON

AFTER COMPLETING A BACHELOR OF ARTS DEGREE IN GRAPHIC DESIGN AT NORWICH SCHOOL OF ART & DESIGN, BRITISH ILLUSTRATOR MICHELLE THOMPSON CONTINUED HER STUDIES IN LONDON, GRADUATING WITH A MASTER OF ARTS DEGREE FROM THE ROYAL COLLEGE OF ART IN 1997. SHE HAS SINCE WORKED ON PROJECTS ENCOMPASSING ADVERTISING, PUBLISHING AND DESIGN. RECENT WORK HAS INCLUDED COMMISSIONS FROM SOME OF THE WORLD'S TOP DESIGNERS, NOTABLY A BILLBOARD CAMPAIGN FOR ITALIAN CLOTHES LABEL ASPESI WITH GRAPHIC DESIGNER VAUGHAN OLIVER'S STUDIO V23. THOMPSON HAS ALSO CREATED ILLUS-TRATIONS FOR BOOK PUBLISHER PENGUIN, THE BOSTON GLOBE AND RECORD LABEL DECCA. SHE USES LETTERPRESS, A CAMERA, SCANNER AND COMPUTER TO CREATE HER IMMACULATELY CRAFTED ILLUSTRATIONS, AND DESCRIBES HER STYLE AS "DIGITAL AND HAND-MADE COLLAGE". INSPIRED BY SURFACE AND COLOUR, THOMPSON ASPIRES "TO HAVE THE LUXURY OF WORKING ON MY OWN PROJECTS".

ABOVE/GLOBAL
OPPOSITE/LEFT/IN A FREE STATE OPPOSITE/RIGHT/THE LOSS OF EL DORADO

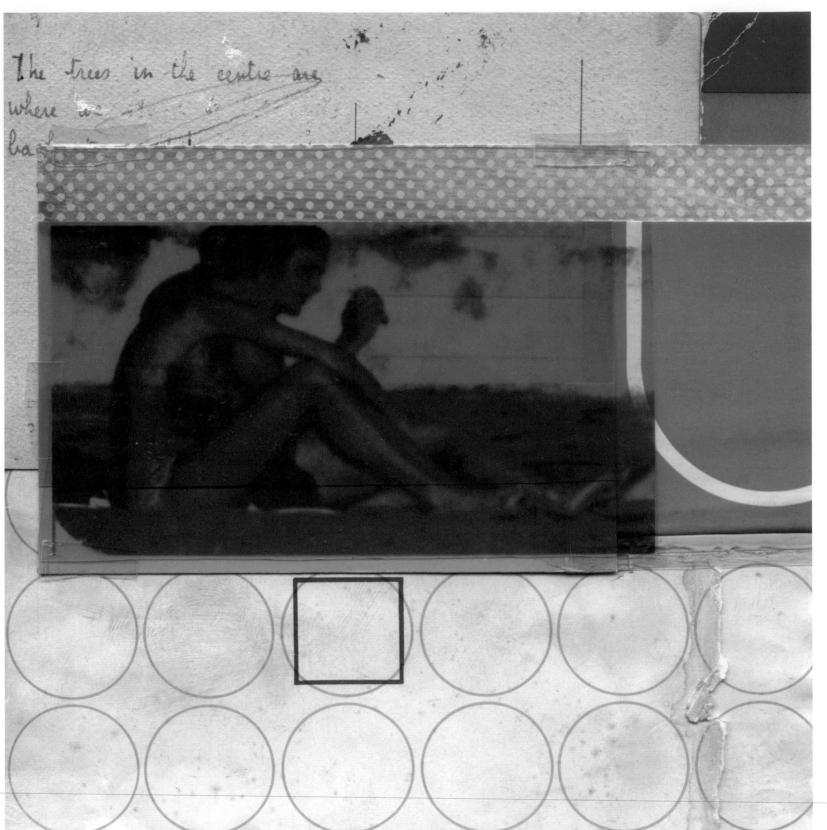

The trees in the centre are
where we
bac

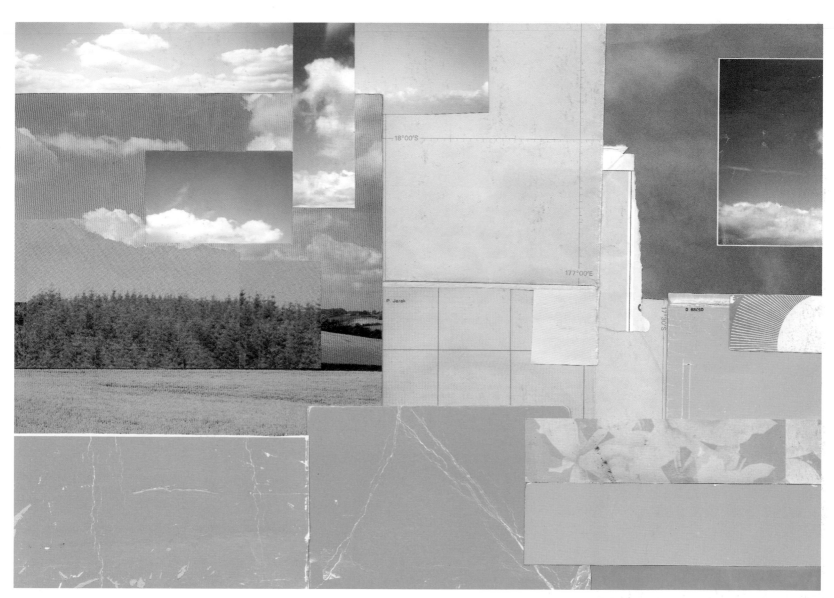

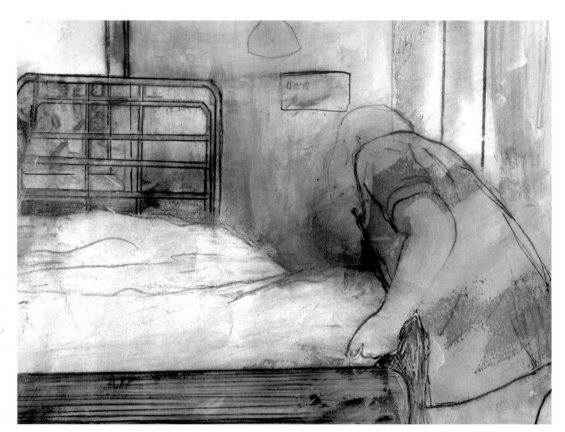

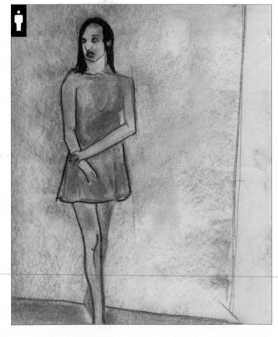

KERRIE JANE STRITTON

ILLUSTRATOR KERRIE JANE STRITTON HAS ALWAYS LOVED ART AND SAYS SHE CHOSE ILLUS-TRATION AS A DIRECTION "TO MAKE IMAGES THAT HAVE MEANING". SHE COMPLETED A BACHELOR OF ARTS DEGREE AT CENTRAL SAINT MARTINS COLLEGE OF ART AND DESIGN IN LONDON, THEN A MASTER OF ARTS DEGREE IN COMMUNICATION ART AND DESIGN AT THE ROYAL COLLEGE OF ART, GRADUATING IN 2002. NOW BASED IN BRIGHTON, HER CLIENTS HAVE INCLUDED THE LONDON PHILHARMONIC ORCHESTRA, FOR WHOM SHE CREATED A LOGO AND ADVERTISING CAMPAIGN IN 2000. SHE DRAWS HER INSPIRATION FROM "MY SURROUNDINGS, THE EVERYDAY, AND PEOPLE'S RELATIONSHIPS WITH THEIR ENVIRONMENT AND EACH OTHER", AND DESCRIBES HER STYLE AS "REAL AND SOMETIMES HARD". HER TOOLS INCLUDE PENCIL, CHARCOAL, ACRYLIC PAINT AND SOMETIMES, IF IT SUITS THE SUBJECT MATTER, A MAC.

ABOVE/MARY CHANGING THE BED
OPPOSITE/LEFT/IRREGULAR HEART BEAT OPPOSITE/RIGHT/STRUCTURE

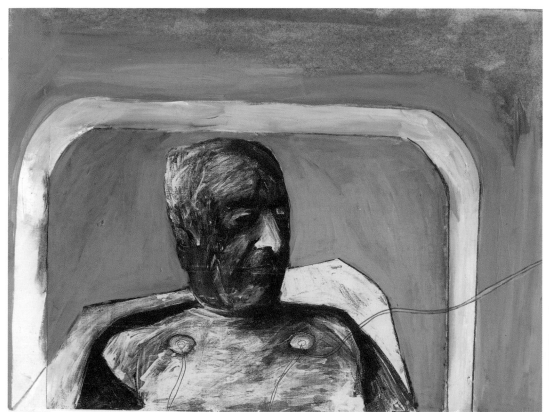

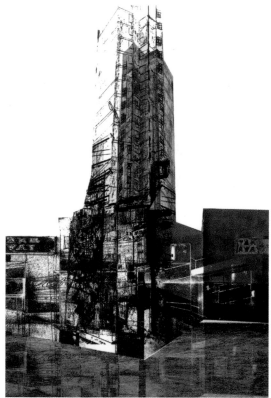

20

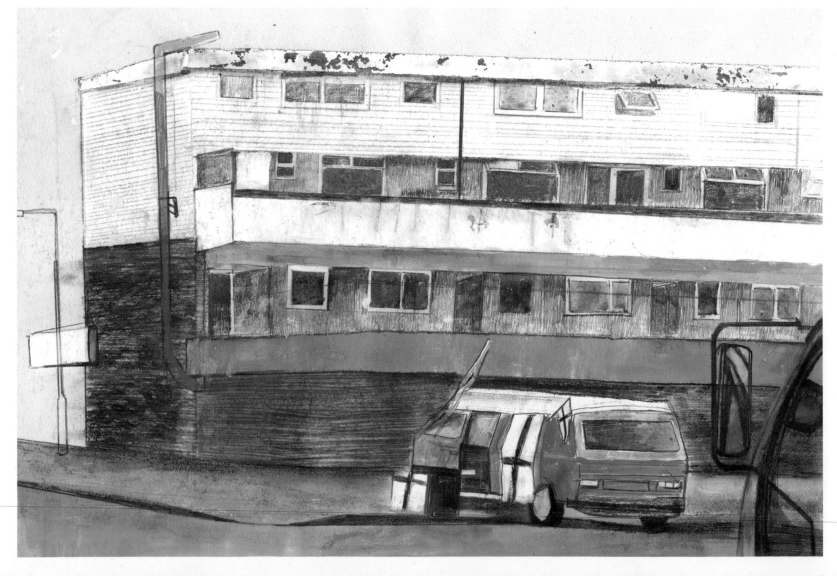

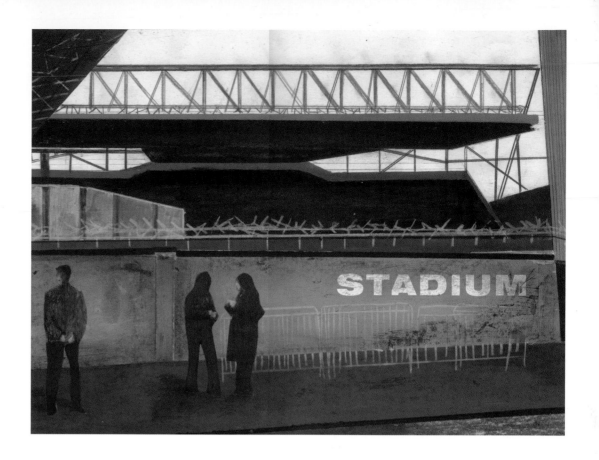

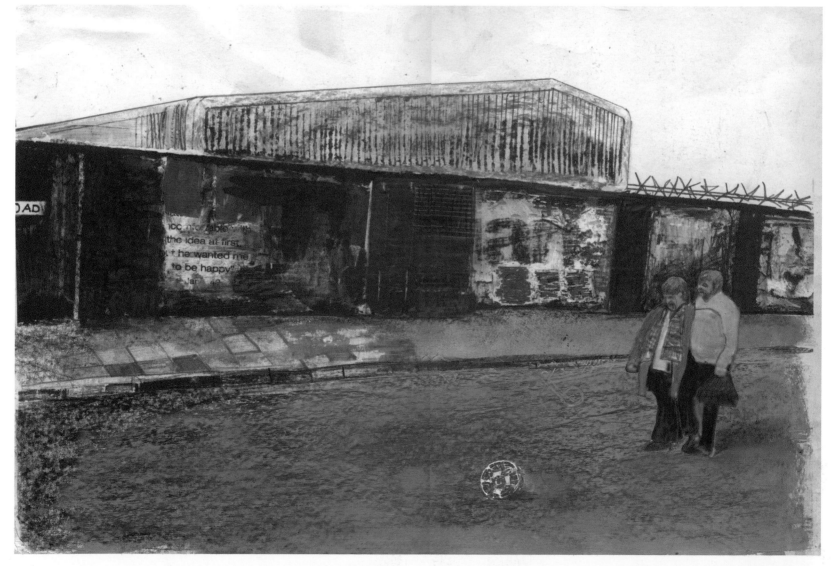

LUCINDA ROGERS

BRITISH ILLUSTRATOR AND ARTIST LUCINDA ROGERS INCORPORATES THE USE OF PEN AND INK, WATERCOLOUR, GOUACHE AND CRAYON IN HER WORK AND DESCRIBES HER STYLE AS "DOCUMENTARY DRAWING FROM LIFE". SHE HAS BEEN BASED IN LONDON FOR THE LAST FIVE YEARS AND HAS WORKED FOR A RANGE OF CLIENTS INCLUDING THE SAVOY GROUP, BARINGS, BRITISH AIRWAYS, HABITAT, PENGUIN AND MOST OF THE BRITISH BROADSHEETS. FOR THE LAST TEN YEARS ROGERS HAS ALSO BEEN WORKING ON A SERIES OF DRAWINGS BASED ON LIFE IN NEW YORK AND VISITS THE CITY ONCE A YEAR. SHE HAS EXHIBITED THIS WORK TWICE, MOST RECENTLY IN 2002 AT LONDON'S OXO GALLERY, ALONGSIDE A NEWER SERIES OF LONDON DRAWINGS. HER AMBITIONS FOR THE FUTURE ARE "TO CONTINUE TO EXHIBIT WORK, TO DRAW IN DIFFERENT CITIES AND TO PRODUCE A BOOK OF DRAWINGS."

BELOW/BEN FREEDMAN, ORCHARD STREET
OPPOSITE/LEFT/DISCOVER THE BIRCHWOODS AT JFK AIRPORT OPPOSITE/RIGHT/GRAND CENTRAL AND THE CHRYSLER BUILDING

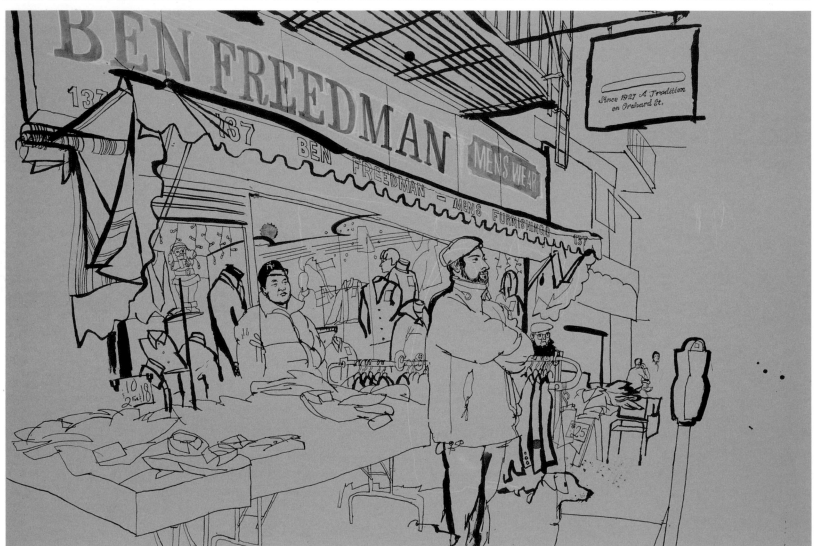

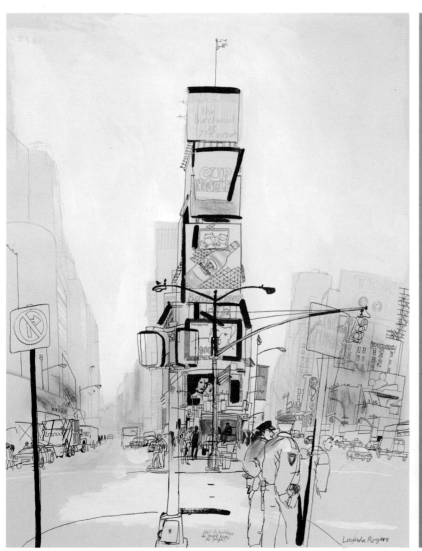

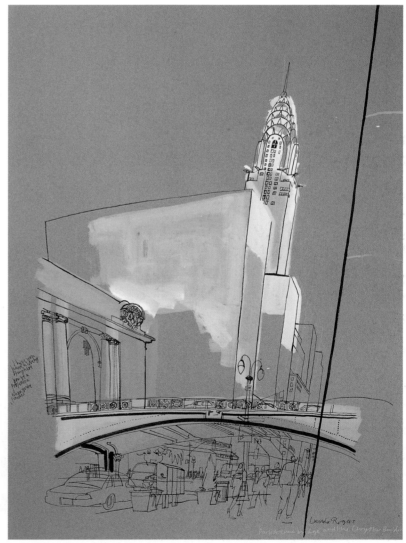

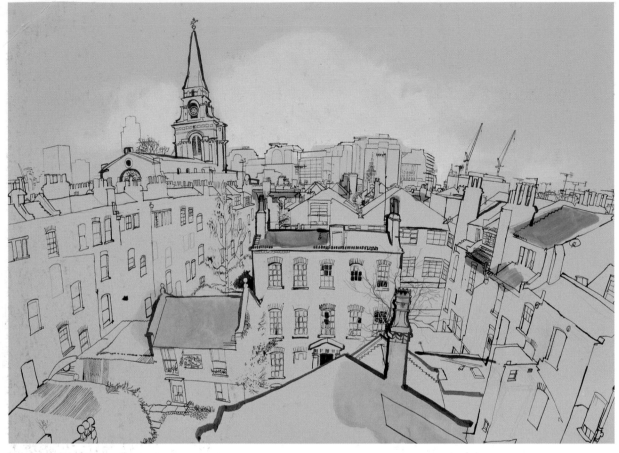

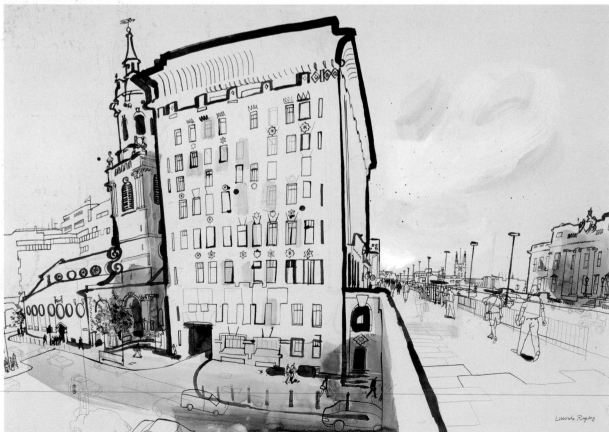

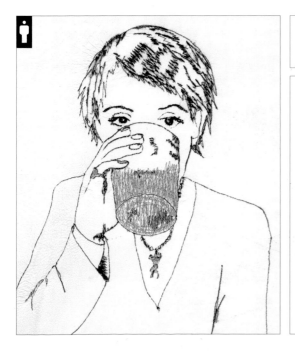

LAURA LEES

EDINBURGH-BORN LAURA LEES USES A BERNINA SEWING MACHINE AND A TAPESTRY FRAME TO CREATE HER UNIQUE PIECES. SHE GRADUATED IN 1997 FROM DUNCAN OF JORDANSTONE COLLEGE OF ART AND DESIGN IN DUNDEE, SCOTLAND WITH A DEGREE IN CONSTRUCTED TEXTILES. TODAY SHE WORKS AS A FREELANCE ARTIST, SPECIALIZING IN EMBROIDERY, LEATHER APPLIQUÉ AND TAPESTRY, AND ATTEMPTS "TO COMBINE TRADITIONAL CRAFT TECHNIQUES WITH CONTEMPORARY IMAGERY". WORKING BOTH AS A SOLO ARTIST AND IN COLLABORATION WITH OTHER ARTISTS, PHOTOGRAPHERS, MUSICIANS AND FASHION DESIGNERS, LEES CREATES ONE-OFF AND LIMITED-EDITION GARMENTS AND PROMOTIONAL ART COLLECTABLES. SHE DESCRIBES HER WORK AS "EXTREMELY LABOUR INTENSIVE AND DETAILED WITH A ROUGH AND READY EDGE".

LEFT/RUSSIAN BAR CENTRE/RED LION RIGHT/CHEAP BOOZE

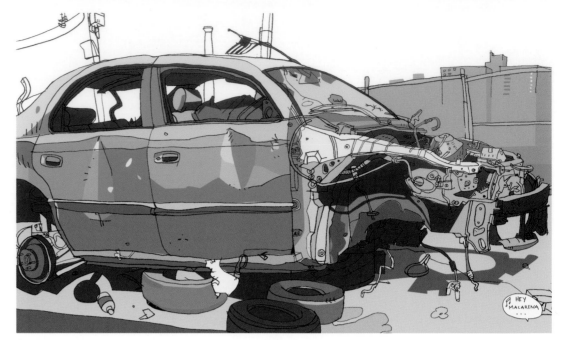

OLIVIER KUGLER

IT WAS AFTER READING THE TINTIN BOOK THE SUN TEMPLE THAT OLIVIER KUGLER FIRST DISCOVERED THAT HE WANTED TO BECOME AN ILLUSTRATOR. BORN IN STUTTGART, KUGLER GRADUATED FROM THE FACHHOCHSCHULE FÜR GESTALTUNG IN PFORZHEIM. HE WORKED AS A GRAPHIC DESIGNER FOR TWO YEARS, THEN WON A SCHOLARSHIP TO THE MFA ILLUSTRATION PROGRAM AT THE SCHOOL OF VISUAL ARTS IN NEW YORK, GRADUATING IN 2002. COMMERCIAL CLIENTS INCLUDE WIEDEN + KENNEDY, THE NEW YORKER, FOLIO, THE GUARDIAN AND READER'S DIGEST. KUGLER ALSO WORKS ON ONGOING PERSONAL PROJECTS: "OVER THE LAST TWO YEARS I HAVE BEEN WORKING ON VISUAL ESSAYS. THESE PORTRAY PEOPLE THAT I HAVE MET IN NEW YORK INCLUDING A HOMELESS MAN WHO INHABITS A CARWRECK IN A PARKING LOT IN SPANISH HARLEM." HIS AMBITION FOR THE FUTURE IS TO COMBINE HIS TWO PASSIONS: DRAWING AND TRAVELLING.

ABOVE/SPREAD FROM THE BOOKLET SPANISH HARLEM PARKINGLOT OPPOSITE/FROM THE BOOKLET FRYING PAN, NYC

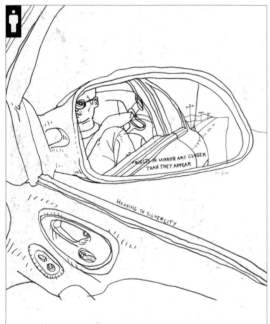

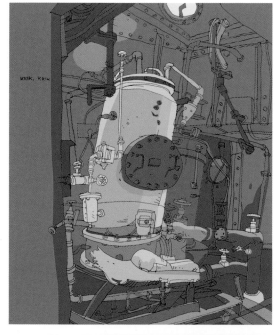

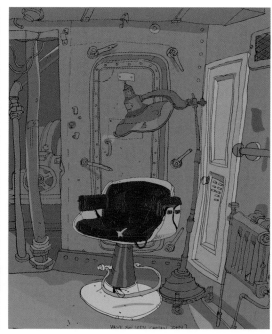

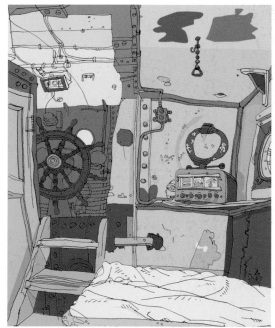

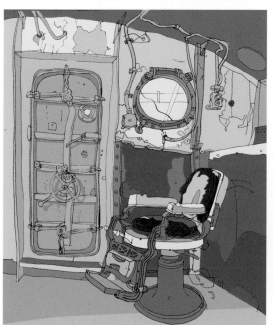

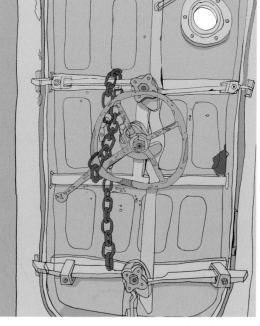

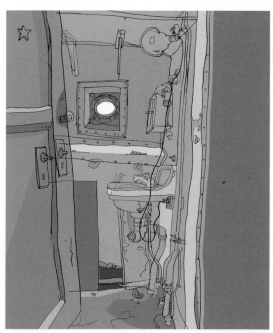

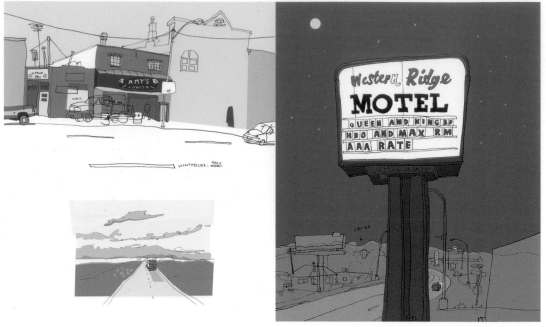

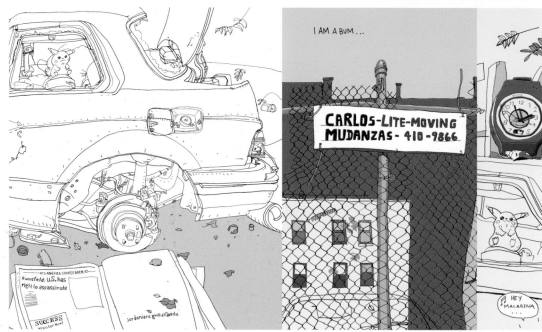

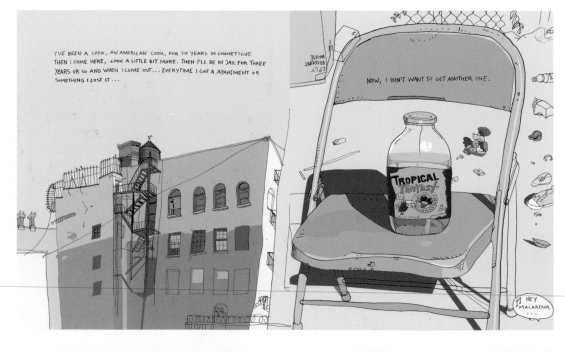

28

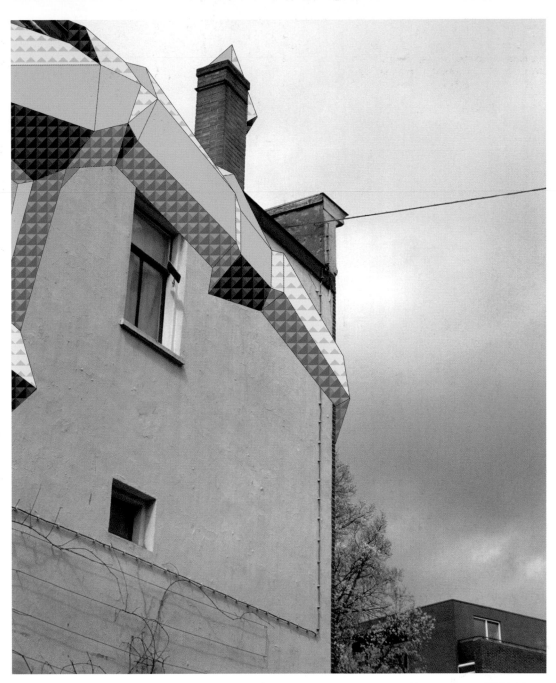

DELTA

DUTCH ARTIST DELTA'S FIRST FORAY INTO THE WORLD OF VISUAL COMMUNICATION WAS IN 1983 WHEN, AT THE AGE OF 15, HE BEGAN TO WRITE GRAFFITI, INFLUENCED BY THE TAGS AND LARGER-SCALE PIECES HE SAW APPEARING IN NEW YORK AND AMSTERDAM. DELTA DESCRIBES HIMSELF AS AN ARTIST/DESIGNER/ILLUSTRATOR. HE RUNS HIS OWN DESIGN AGENCY INCD (NAMED AFTER HIS OLD GRAFFITI CREW, INC, WITH HIS INITIAL TACKED ON THE END) IN AMSTERDAM, WHERE HE HAS LIVED SINCE THE AGE OF FIVE. USING MAINLY PENCIL, ACRYLICS AND WOOD, HE ALSO EMPLOYS A COMPUTER FOR TRACING AND MANIPULATING HIS DESIGNS WHICH ARE INSPIRED BY ABSTRACT LETTERING AND 3D OBJECTS AND ENVIRONMENTS. CLIENTS TO DATE INCLUDE RELAX, IDN, DUTCH MAGAZINE VOLKSRANT, NINJA TUNE, NIKE, CALVIN KLEIN AND LINKIN PARK. HE HAS EXHIBITED INTERNATIONALLY ALONGSIDE THE LIKES OF FUTURA AND MODE 2.

ABOVE/AMS-X

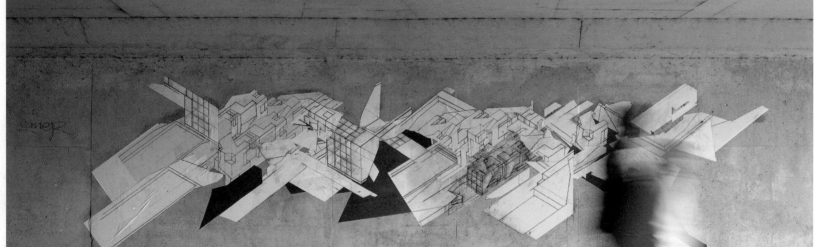

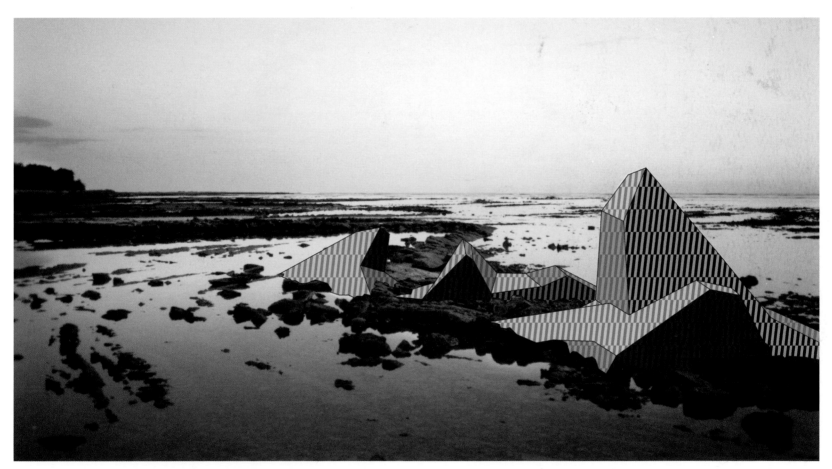

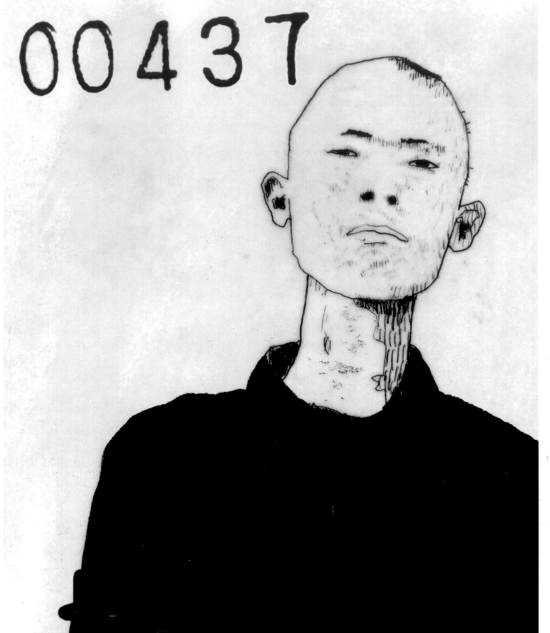

00437

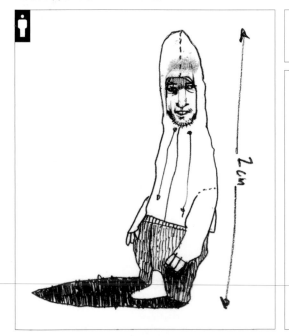

DAVID FOLDVARI

A COMBINATION OF FACTORS LED HUNGARIAN DAVID FOLDVARI TO PURSUE A CAREER AS AN ILLUSTRATOR, INCLUDING THE EARLY INFLUENCE OF RENOWNED HUNGARIAN ILLUSTRATOR AND FAMILY FRIEND, TEDDY BANO, AS WELL AS THE EXPERIENCE OF SEEING HIS OWN WORK PUBLISHED FOR THE FIRST TIME IN THE PROLIFIC 1980S SKATE MAGAZINE RAD AT THE AGE OF 15. WITH CLIENTS INCLUDING NIKE, DAZED & CONFUSED, PENGUIN, RANDOM HOUSE AND LONDON RECORDS, FOLDVARI'S STRIKING WORK INCORPORATES THE USE OF PENCIL, PHOTO-COPYING AND A FAX MACHINE BEFORE REACHING HIS MAC. AMBITIONS FOR THE FUTURE INCLUDE DEVELOPING IDEAS FOR A SERIES OF PERSONAL BOOKS. FOLDVARI CITES HIS MAIN INSPIRATIONS AS EASTERN EUROPEAN POLITICAL GRAFFITI; HARMONY KORINE FILMS GUMMO AND JULIEN DONKEY-BOY; DRUM AND BASS; PIRATE RADIO AND GRIM CITIES.

ABOVE/VICTIM00437 OPPOSITE/LEFT/STARBUCKS COVER PROTOTYPE VERSION
OPPOSITE/RIGHT/ALBUM COVER FOR HIFI SERIOUS BY THE BAND A

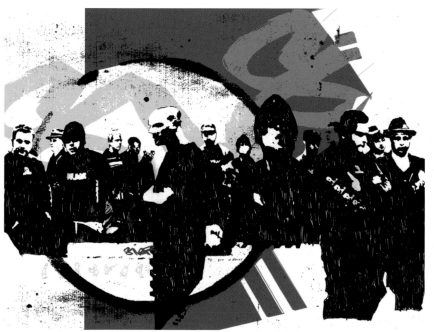 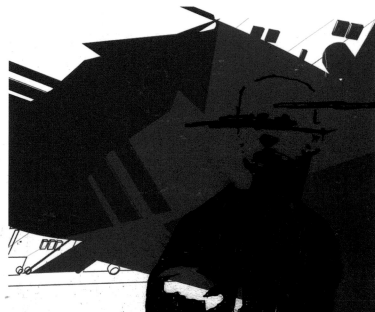

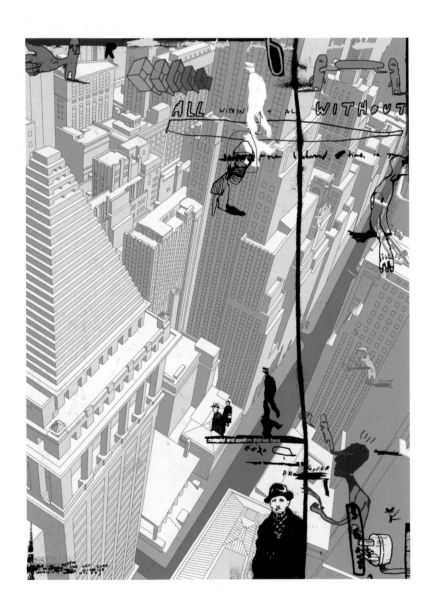

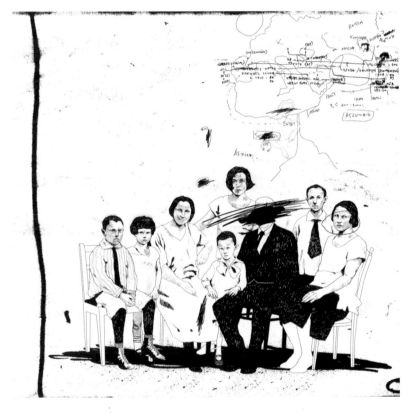

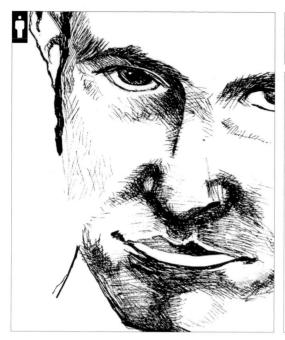

RICHARD BEACHAM

RICHARD BEACHAM DIDN'T ALWAYS WANT TO BE AN ILLUSTRATOR: "I HAD ORIGINALLY CONSIDERED ARCHITECTURE," HE EXPLAINS, "BUT I WAS SCARED OFF WHEN I REALIZED THAT THE 'DRAWING BOARD' APPROACH WAS ALREADY REDUNDANT AND COMPUTER-AIDED DESIGN WAS THE FUTURE, LEAVING PRECIOUS LITTLE ROOM FOR DRAUGHTSMANSHIP." ONE OF TWELVE UK-BASED ILLUSTRATORS WHO FORM THE PEEPSHOW COLLECTIVE, BEACHAM DESCRIBES HIS STYLE AS "FIGURATIVE AND SEMI-REALIST". ALTHOUGH HE ALSO PRODUCES DIGITAL COLLAGE PIECES, HIS INTRICATELY DETAILED HAND-RENDERED ILLUSTRATIONS ARE FEATURED HERE. "I USE HARD BOARD ROUGHLY PRIMED WITH WHITE ACRYLIC, THEN A 4H PENCIL OVER THE TOP. THE IMAGE IS FINISHED WITH EITHER BLACK OR WHITE ACRYLIC TO BLOCK IT IN." THE ILLUSTRA-TION IS SCANNED, THEN REFINED ON A MAC. COMMERCIAL COMMISSIONS TO DATE INCLUDE EDITORIAL ILLUSTRATIONS FOR THE INDEPENDENT ON SUNDAY AND SLEAZENATION MAGAZINE.

TOP/LEFT/GRAVE TOP/RIGHT/HEART
BOTTOM/LEFT/TABLE BOTTOM/RIGHT/TRAP

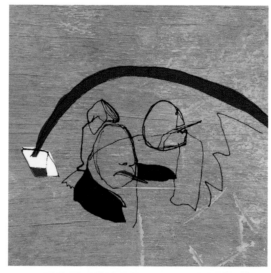
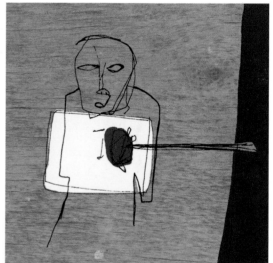
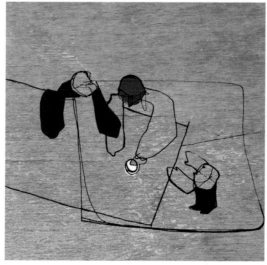
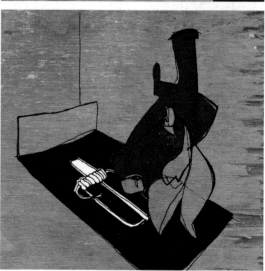

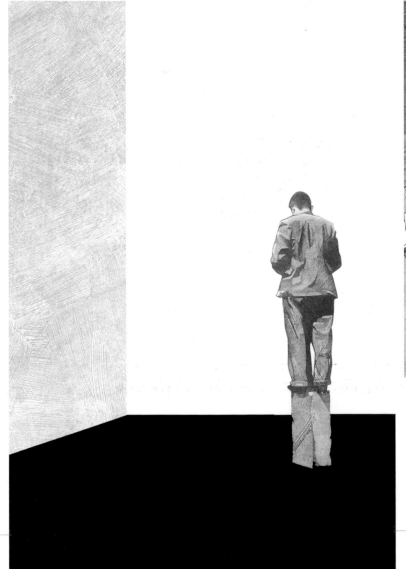

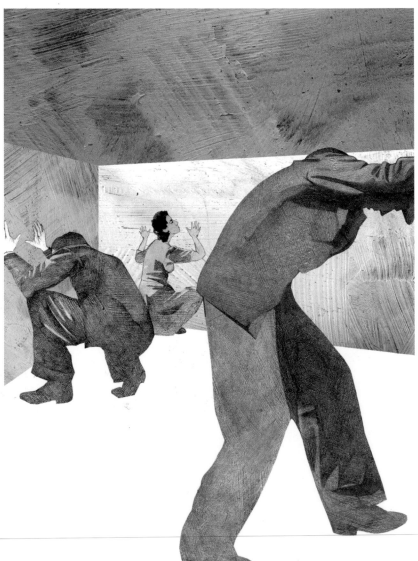

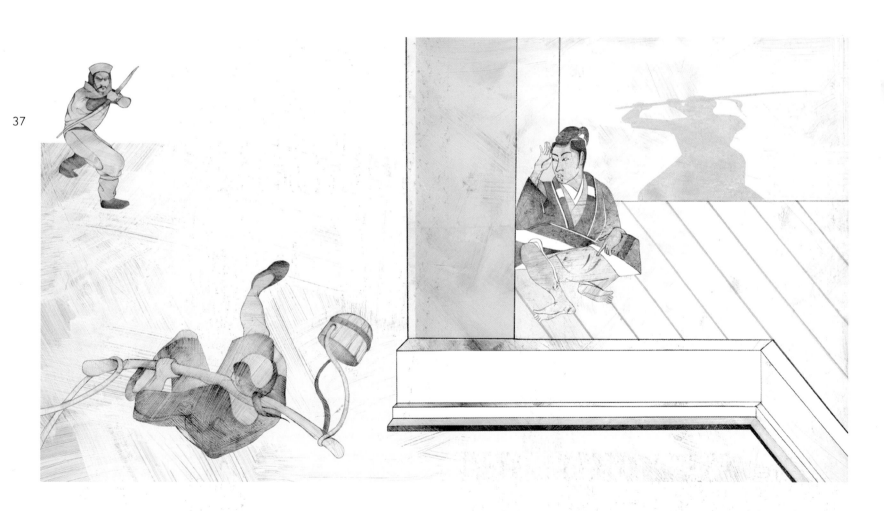

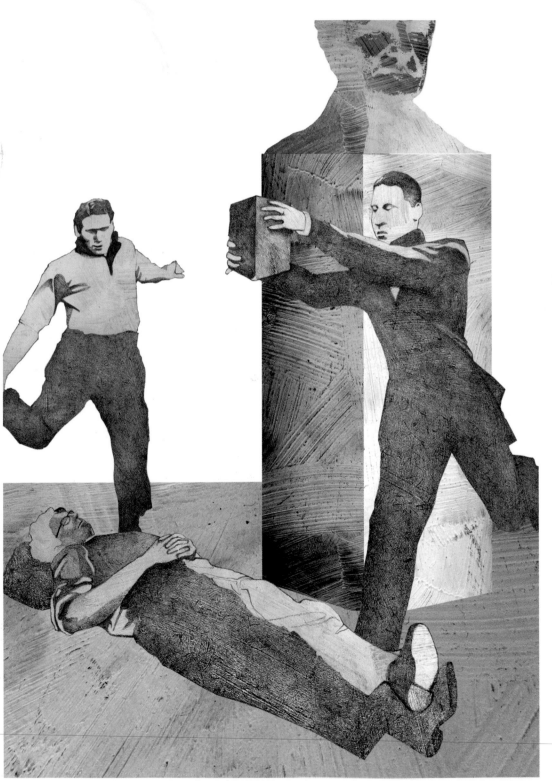

38

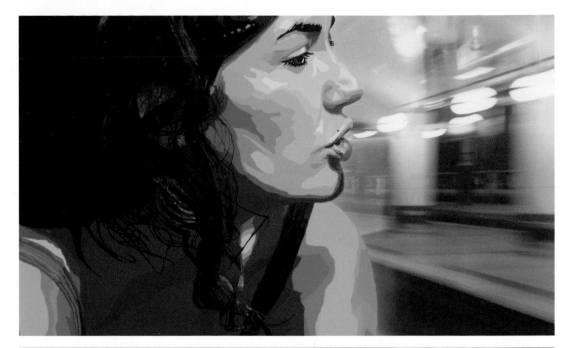

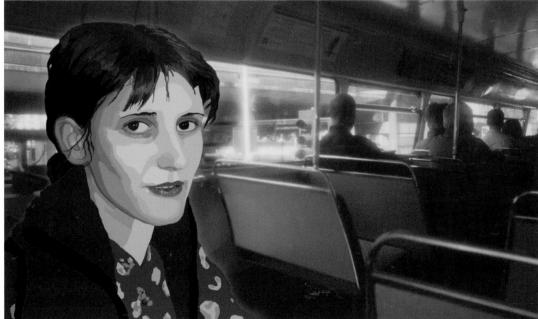

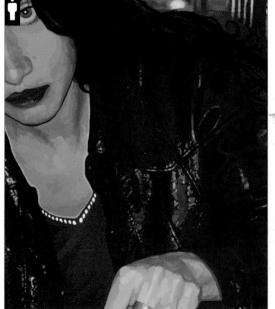

MARION LEFEBVRE

FRENCH ILLUSTRATOR AND FINE ARTIST MARION LEFEBVRE HAS BEEN PASSIONATE ABOUT CREATING IMAGES SINCE SHE WAS A CHILD. AFTER GRADUATING WITH A BACHELOR OF ARTS DEGREE IN ILLUSTRATION FROM THE KENT INSTITUTE OF ART AND DESIGN IN MAIDSTONE IN THE UK IN 1995, SHE RETURNED TO FRANCE TO TAKE A MASTER OF ARTS DEGREE IN FINE ART AT L'ECOLE DES BEAUX-ARTS IN TOULOUSE. HER COMMISSIONS HAVE INCLUDED VARIOUS PROJECTS FOR PUBLISHERS HARPERCOLLINS AND PENGUIN, AND MAGAZINES TIME OUT AND STRAIGHT NO CHASER. LEFEBVRE'S PIECES ARE CREATED FROM A COMBINATION OF HER OWN PHOTOGRAPHY AND DRAWING, THEN ARTWORKED USING PHOTOSHOP ON A MAC. WITH ASPIRATIONS TO ESTABLISH HERSELF INCREASINGLY AS A FINE ARTIST, LEFEBVRE ALSO EXHIBITS INTERNATIONALLY, MOST RECENTLY AS PART OF LES RENCONTRES D'ARLES INTERNATIONAL FESTIVAL OF PHOTOGRAPHY.

TOP/MATOO BOTTOM/LONDON

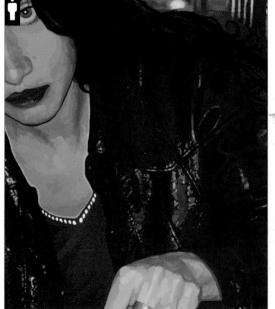

39

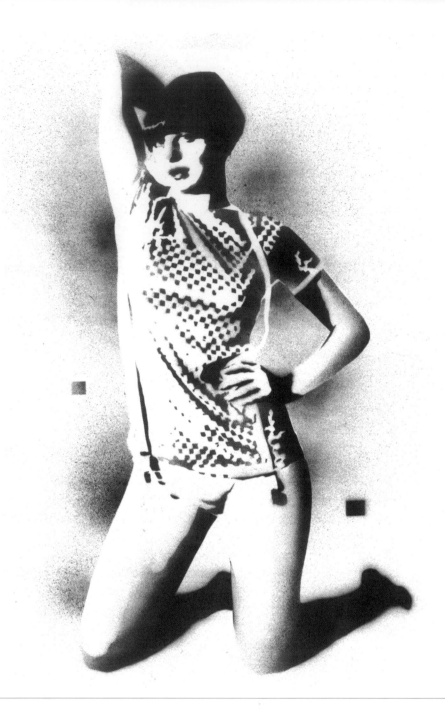

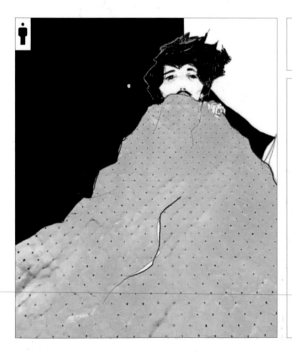

BERNIE REID

EDINBURGH-BORN ILLUSTRATOR BERNIE REID IS TODAY BASED IN LONDON. SELF-TAUGHT, REID GOT HIS FIRST BREAK WHEN A COLLABORATION WITH STYLIST AND FASHION DESIGNER BECA LIPSCOMBE AND PHOTOGRAPHER ANDY SHAW WAS POSITIVELY REVIEWED BY I-D MAGAZINE (ISSUE 197). THIS WAS QUICKLY FOLLOWED BY A 10-PAGE FASHION STORY COMMISSION FOR NOVA MAGAZINE (JANUARY 2001) WHICH ENABLED BERNIE TO "ENFORCE THE STREET ROOTS ELEMENT" OF HIS WORK BY STENCILLING ARTWORKS, FEATURING UPMARKET FASHION LABEL CLOTHING AND ACCESSORIES, DIRECTLY ON TO EXTERIOR WALLS AND URBAN LANDSCAPES. OTHER CLIENTS INCLUDE STELLA MCCARTNEY, BOXFRESH, DAZED & CONFUSED AND THE INDEPENDENT ON SATURDAY MAGAZINE, AS WELL AS COVER ARTWORK FOR JAPANESE RECORD LABEL STUDIO VOICE. REID CITES "MUSIC, WORKING-CLASS ECCENTRICITY AND BECA" AMONG HIS MAIN INSPIRATIONS. HE HAS RECENTLY BEEN DEVELOPING NEW DIRECTIONS IN HIS WORK BY ADDING FIGURATIVE PHOTOGRAPHY, PEN/PENCIL DRAWING AND COLLAGE TO THE MIX.

ABOVE/LUCY FOR STELLA N.Y.C. OPPOSITE/TOVE

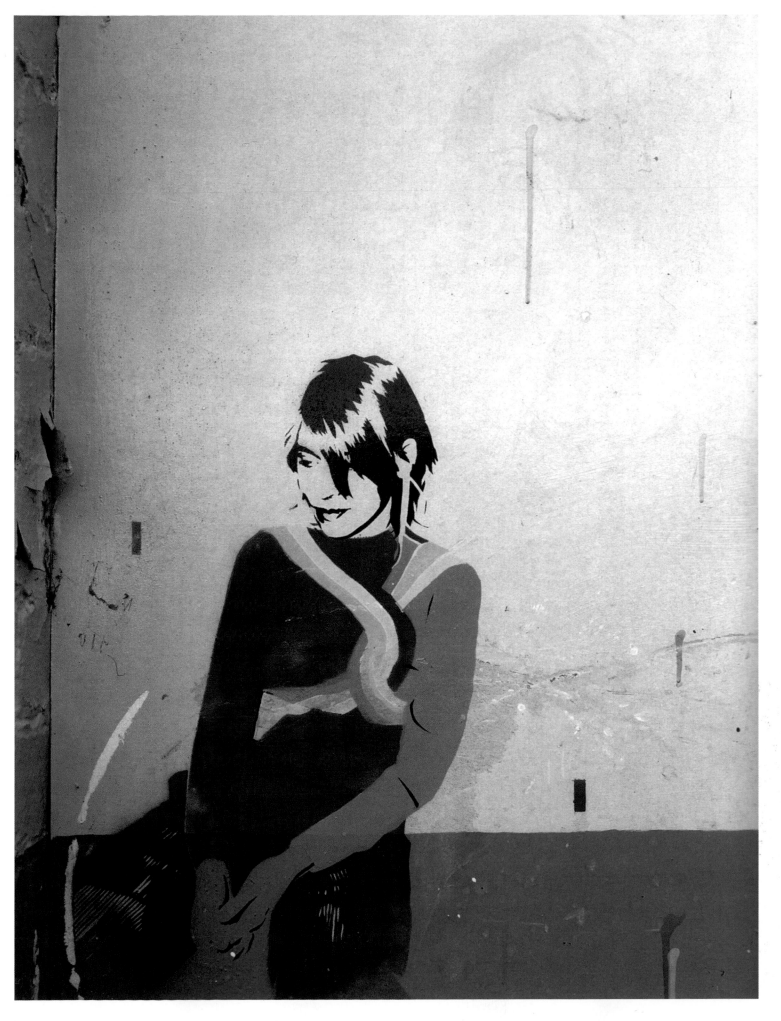

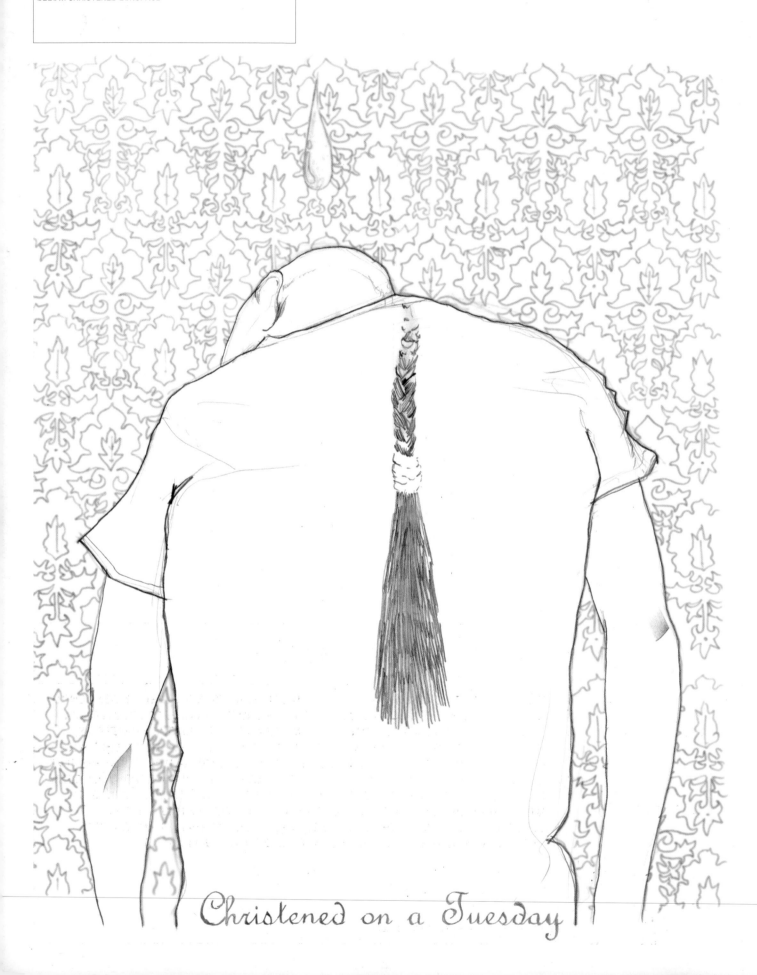

Christened on a Tuesday

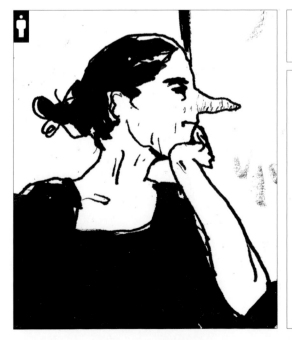

ISABEL BOSTWICK

AFTER TRAINING AT GLASGOW SCHOOL OF ART IN SCOTLAND, ISABEL BOSTWICK WENT ON TO GRADUATE WITH A MASTER OF ARTS DEGREE FROM THE ROYAL COLLEGE OF ART IN LONDON IN 2002, BEFORE RETURNING TO HER HOME TOWN OF BRIGHTON TO PURSUE A CAREER AS A FREELANCE ILLUSTRATOR. BOSTWICK CREATES HER DRAWINGS USING MAINLY INK BUT ALSO CRAYONS, OILS, COLOURED PENCIL, PHOTOCOPIES, SCRAPERBOARD, OLD PHOTOGRAPHS THAT SHE CUTS UP AND, FINALLY, A COMPUTER. TO DATE BOSTWICK HAS WORKED WITH ARCHITECT NIGEL COATES ON A SERIES OF PLATES AND GLASSES INSPIRED BY BARNABA FORNASETTI, AND ON FASHION ADVERTISING FOR JOE CASELY-HAYFORD. SHE HAS HAD ARTWORK PUBLISHED IN THE MAGAZINE THE ILLUSTRATED APE AND IS CURRENTLY ILLUSTRATING A SERIES OF SHORT STORIES ABOUT THE NORSE GODS BY WRITER JAMES BURT.

ABOVE/THE CAT WHO GOBBLES OTHER GOBBLERS

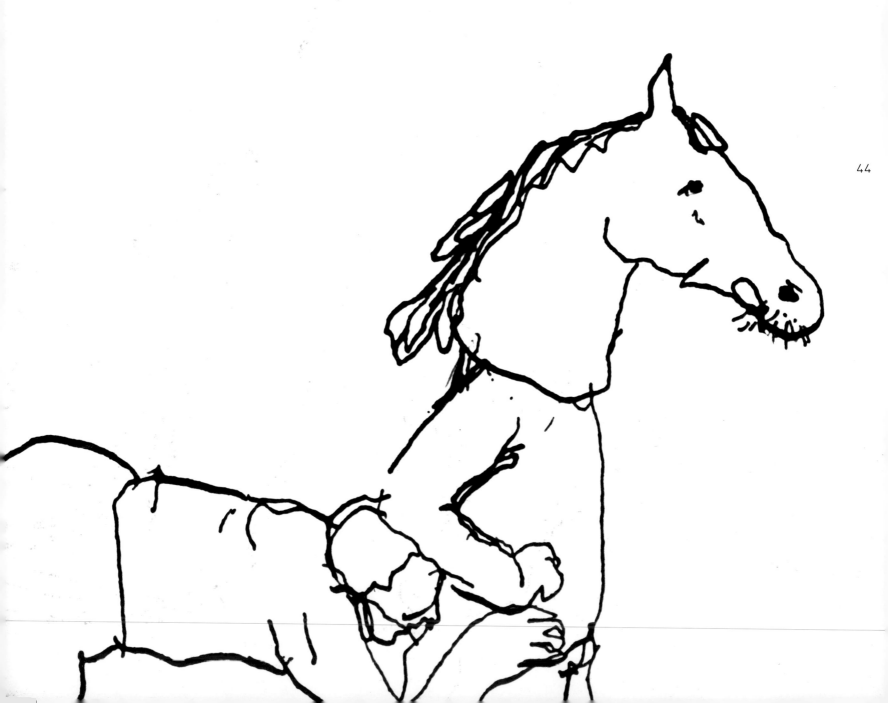

44

45

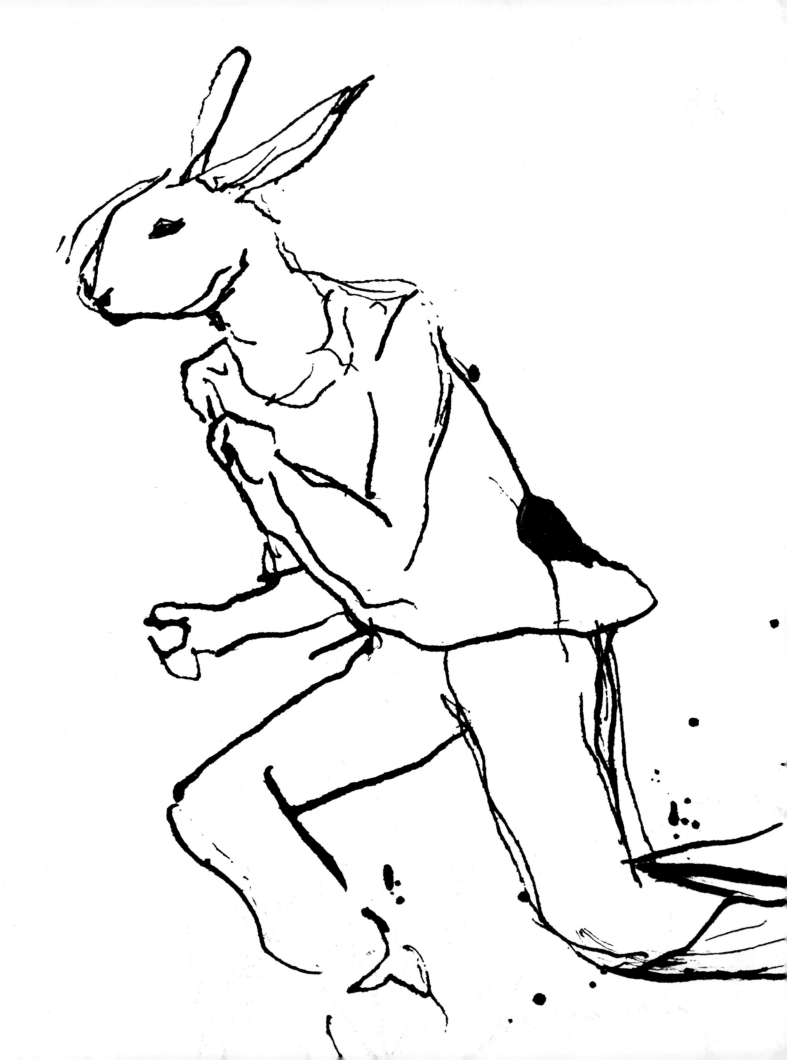

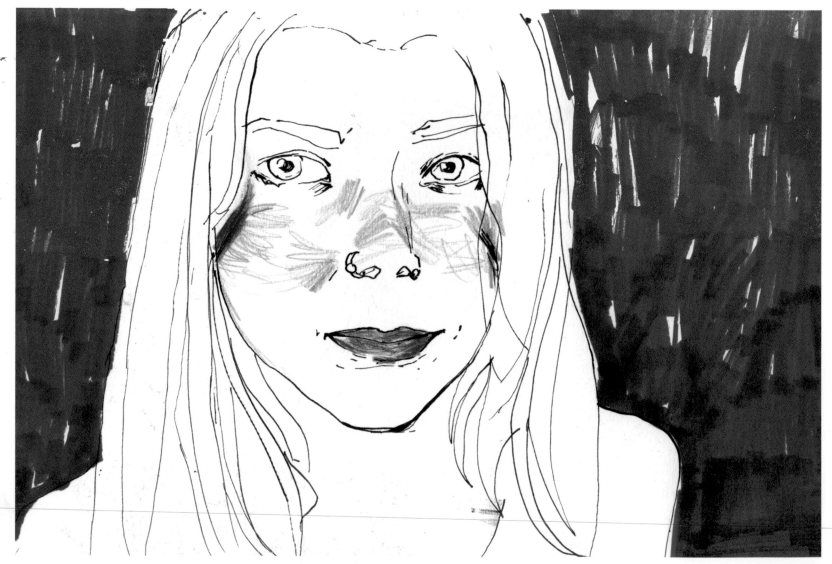

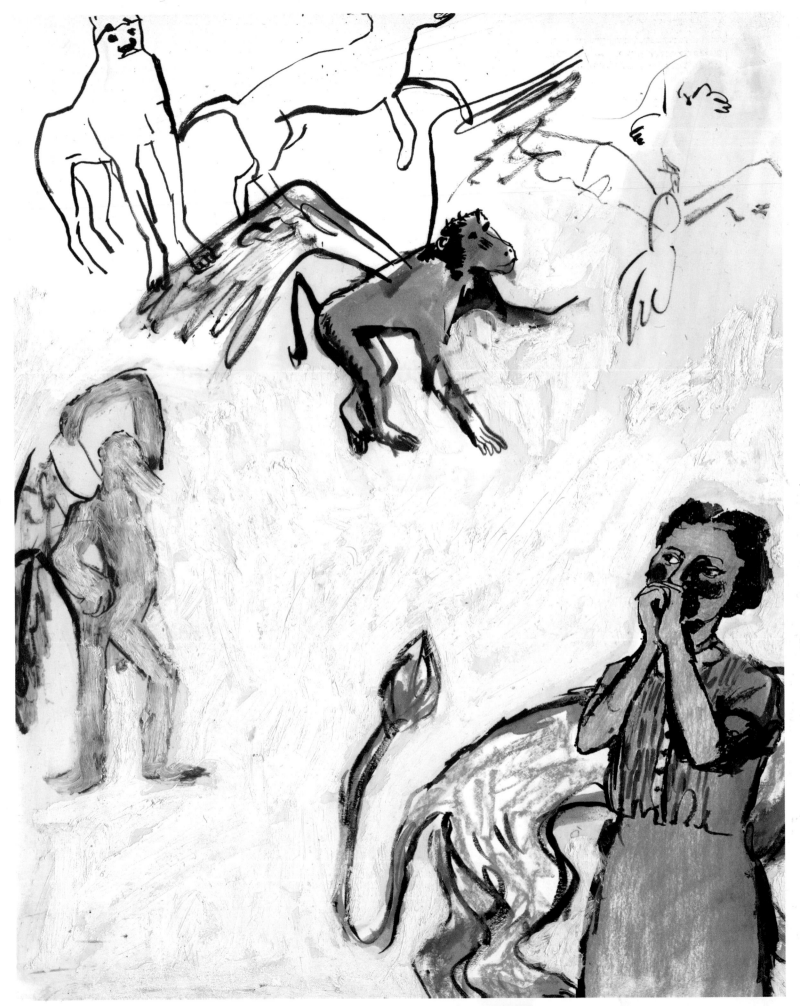

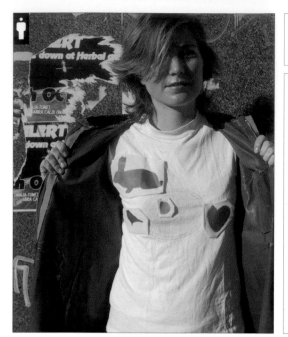

FRAUKE STEGMANN

FREELANCE GRAPHIC DESIGNER AND ILLUSTRATOR FRAUKE STEGMANN GREW UP IN NAMIBIA WHERE THE LANDSCAPE AND HER MOTHER WERE GREAT INFLUENCES. "MY MOTHER TAUGHT ME HOW TO APPRECIATE THE BOUNDARIES OF FORM. WHEN WE WERE ON THE ROAD IN NAMIBIA, SHE WOULD ALWAYS TELL US TO LOOK – NOT JUST LOOK, BUT REALLY LOOK AT THE ENDLESS STRETCHES OF OVERWHELMINGLY UNSPOILT NATURE." SHE GAINED A BACHELOR OF ARTS DEGREE IN GRAPHIC DESIGN IN MAINZ, GERMANY, BEFORE MOVING TO LONDON TO STUDY FOR A MASTER OF ARTS IN COMMUNICATION ART AND DESIGN AT THE ROYAL COLLEGE OF ART. SINCE GRADUATING SHE HAS WORKED FOR DAVID JAMES ASSOCIATES ON PRADA AND MIU MIU AS WELL AS FREELANCING FOR VARIOUS CLIENTS. STEGMANN USES A VARIETY OF MATERIALS AND PRINTING PROCESSES TO PRODUCE SURPRISING, TEXTURED WORK.

BELOW/LEFT/VEERY/CATHARUS FUSCESCENS
BELOW/RIGHT/POSTER FOR TALK BY DAVID CARSON
OPPOSITE/LEFT/WEDDING INVITATION FOR CAMILLE BIDAULT-WADDINGTON AND JARVIS COCKER
OPPOSITE/RIGHT/FRAUKE STEGMANN LETTERHEAD/STATIONERY

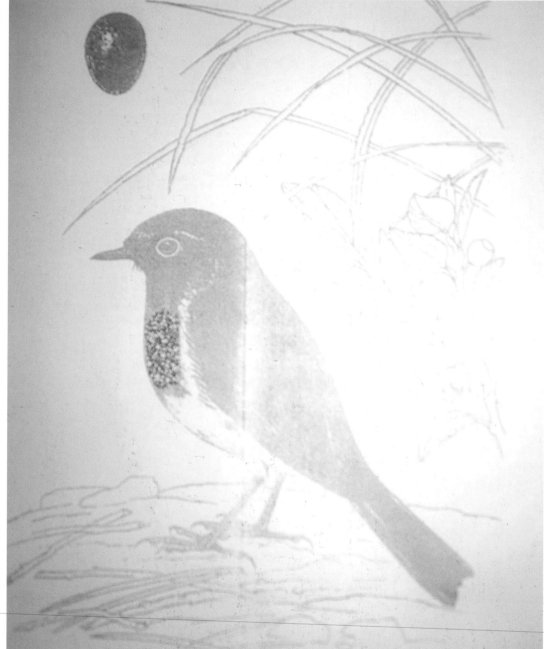

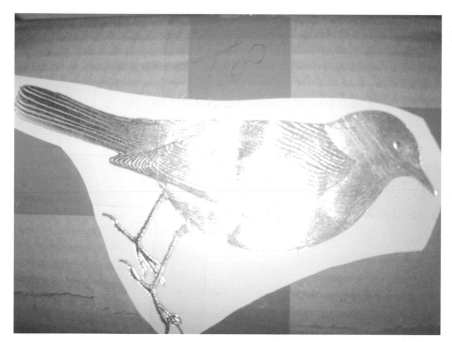

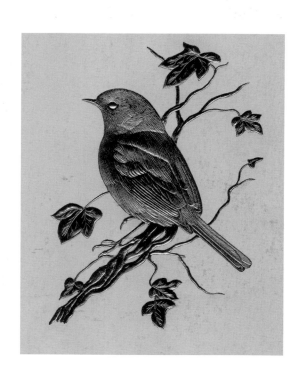

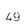

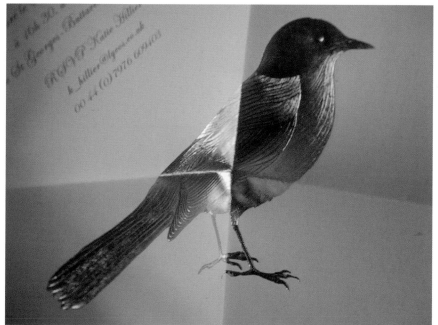

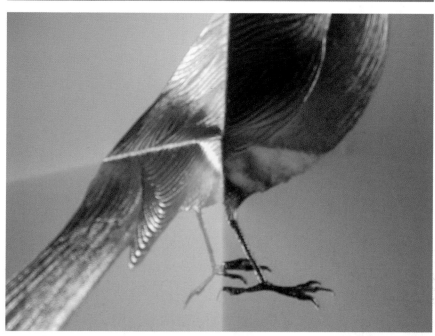

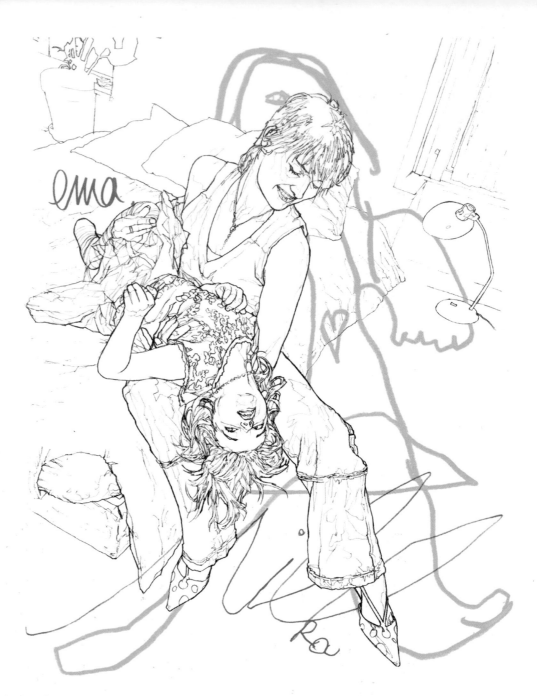

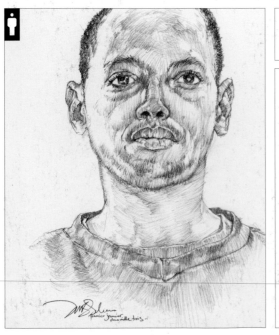

MODE 2

"I DESCRIBE MYSELF AS A PAINTER AND ILLUSTRATOR," EXPLAINS MODE 2. "IT SOUNDS LIKE A CRAFT AS OPPOSED TO SOMETHING ARTY." BORN IN MAURITIUS, MODE 2 IS NOW BASED PREDOMINANTLY IN PARIS. SELF-TAUGHT, HE USES PENCIL, ACRYLIC PAINT AND, INCREASINGLY, A MAC TO CREATE ILLUSTRATIONS THAT ARE BEAUTIFULLY CRAFTED TO THE TINIEST DETAIL. INITIALLY INFLUENCED BY COMICS OF THE LATE SEVENTIES AND EARLY EIGHTIES, HIS ARTWORK HAS ALSO DRAWN INSPIRATION FROM HIP HOP MUSIC AND GRAFFITI WRITING. MODE 2 HAS WORKED ON COMMERCIAL COMMISSIONS FOR CARHARTT, FOR WHOM HE DEVISED THE SPRING/SUMMER 2001 PRESS AND IN-STORE GRAPHICS CAMPAIGN, AND FRENCH HIP HOP ACT SAÏAN SUPA CREW. HE IS ALSO INVOLVED IN THE ANNUAL INTERNATIONAL BATTLE OF THE YEAR B-BOY EVENT, CREATING ALL THE PROMOTIONAL ARTWORK AND ALSO SITTING ON ITS COMMITTEE, RESEARCHING THE EVOLUTION OF THIS PARTICULAR DISCIPLINE OF HIP HOP.

ABOVE/EMA PLAYING WITH HER DAUGHTER MILKA
OPPOSITE/TOP/MAÏ, JONONE (HUSBAND AND FAMOUS GRAFFITI WRITER), AND THEIR DAUGHTER TAÏKA
OPPOSITE/BOTTOM/ONE OF TWO VISUALS FOR ROSS ALLEN'S BLUE LABEL IN EARLY 2001

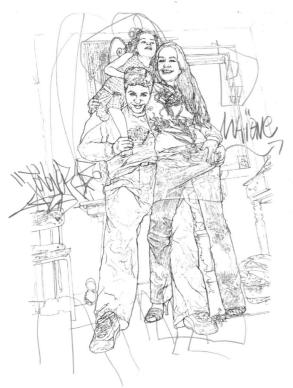

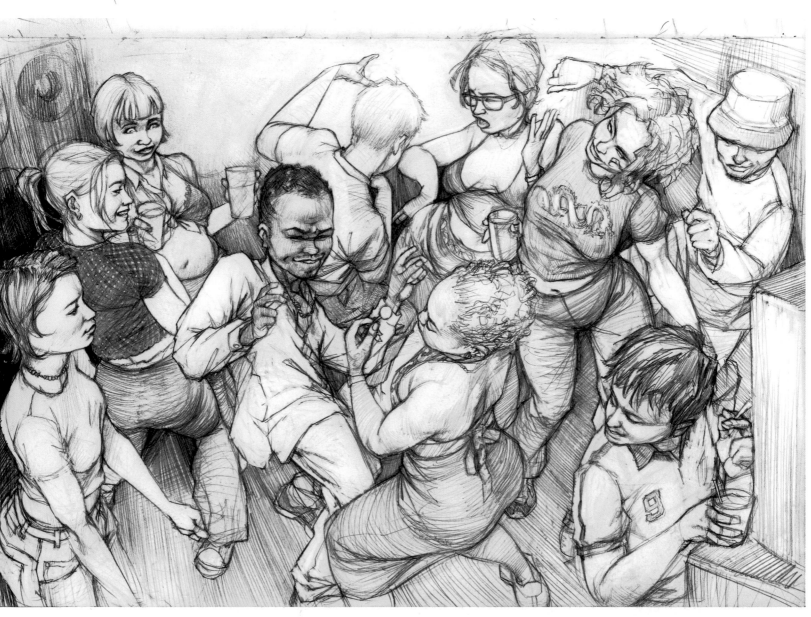

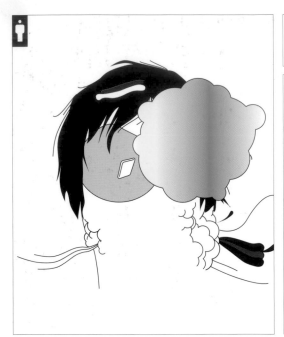

LAURENT FÉTIS

LAURENT FÉTIS FOUNDED HIS OWN DESIGN STUDIO TO ART DIRECT ADVERTISING CAMPAIGNS FOR A LOCAL RADIO STATION WHILE STILL A STUDENT AT THE ECOLE NATIONALE SUPÉRIEURE DES ARTS DÉCORATIFS, PARIS. COMMISSIONS SINCE THEN HAVE INCLUDED THE ART DIRECTION OF FASHION STORIES FOR VOGUE; THE CREATION OF ILLUSTRATIONS FOR THE FACE AND GRAPHIC DESIGN FOR MGM, JVC, UNIVERSAL AND VIRGIN. MUCH OF HIS TIME IS DEDICATED TO CREATING SLEEVES FOR RECORD LABELS INCLUDING EAST WEST UK, TRATTORIA, ATMOSPHÈRIQUES, DELABEL, UNIVERSAL AND GEFFEN, AND HE HAS ALSO CONTRIBUTED ARTWORK TO THE CENTRE GEORGES POMPIDOU, THE FRENCH NATIONAL LIBRARY, FONDS RÉGIONAL D'ART CONTEMPORAIN (FRAC) ILE-DE-FRANCE AND THE FRENCH MINISTRY OF CULTURE. FÉTIS' WORK TYPICALLY COMBINES PHOTOGRAPHY, ILLUSTRATION AND GRAPHICS: "I DON'T WANT TO BE KNOWN AS AN ILLUSTRATOR BECAUSE THEN IT SEEMS YOU HAVE TO DEVELOP ONE STYLE FOR WHICH YOU ARE RECOGNIZED. I DON'T WANT TO DO THAT."

BELOW/COVER FOR MELLOW MAXI "AUTUMN"
OPPOSITE/POSTER FOR HIDEKI KAJI

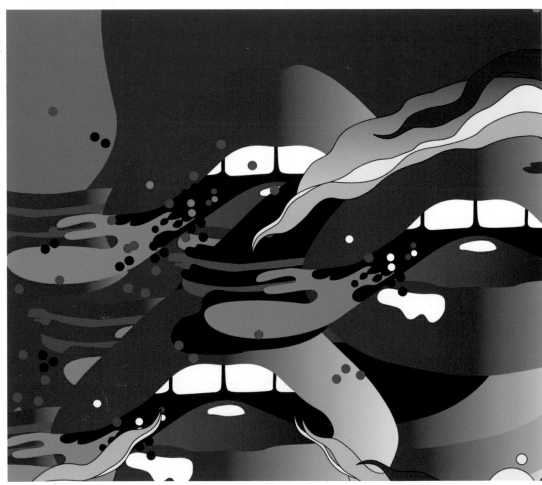

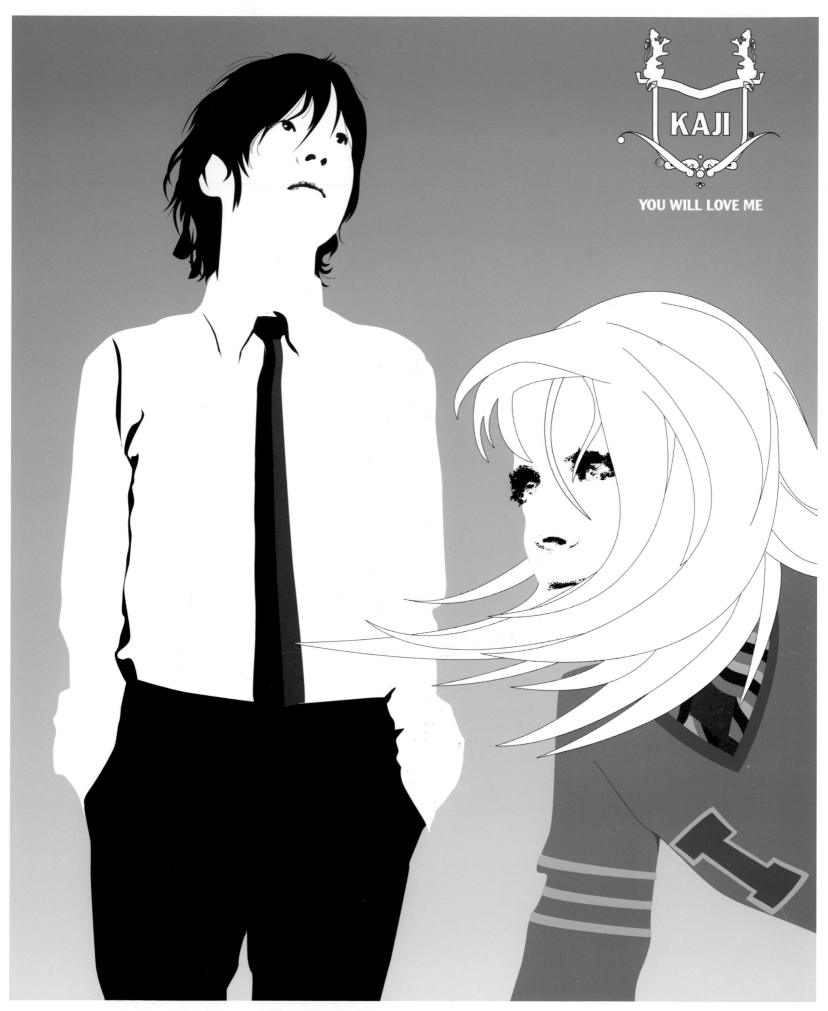

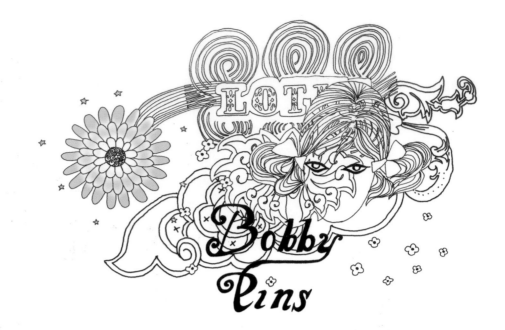

NINA CHAKRABARTI

"DRAWING WAS ONE OF THE FIRST THINGS I WAS GOOD AT AND LOVED DOING", EXPLAINS CALCUTTA-BORN ILLUSTRATOR NINA CHAKRABARTI WHOSE CLIENTS INCLUDE HABITAT, FRENCH CONNECTION AND VOGUE. SHE DESCRIBES HER STYLE AS "DETAILED, DECORATIVE AND DELIGHTFUL", ADDING THAT IT IS "NOT TOO DEEP OR MEANINGFUL, BUT RATHER WHAT SOME PEOPLE MIGHT TERM 'GIRLY', AS THE SUBJECT MATTER IS OFTEN WOMEN'S FASHION AND ACCESSORIES AND AN OBSESSION WITH FLOWERS, PATTERNS AND SPARKLY THINGS SEEMS TO DOMINATE". RECENT COLLABORATIONS WITH DIRECTORS AND MOVING-IMAGE DESIGNERS HAVE LED TO A POTENTIAL CHANGE IN DIRECTION FOR CHAKRABARTI. SHE IS CURRENTLY COMPLETING A MASTER OF ARTS DEGREE IN COMMUNICATIONS AT THE ROYAL COLLEGE OF ART, LONDON, WHERE SHE HOPES TO "MAKE MY DRAWINGS MOVE AND, SINCE I LOVE MUSIC SO MUCH, COMBINE THEM WITH SOUND". CITED INSPIRATIONS INCLUDE "PEOPLE, WHAT THE GIRLS WEAR IN BRIXTON, CHOCOLATE WRAPPERS AND EMBROIDERY".

ABOVE/BOBBY PINS AND THINGS BELOW/LEFT/HAPPY DAY WITH SARAH BELOW/RIGHT/THANK-YOU FOR EVERYTHING
OPPOSITE/HELL IS...

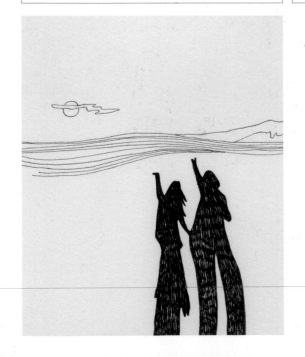

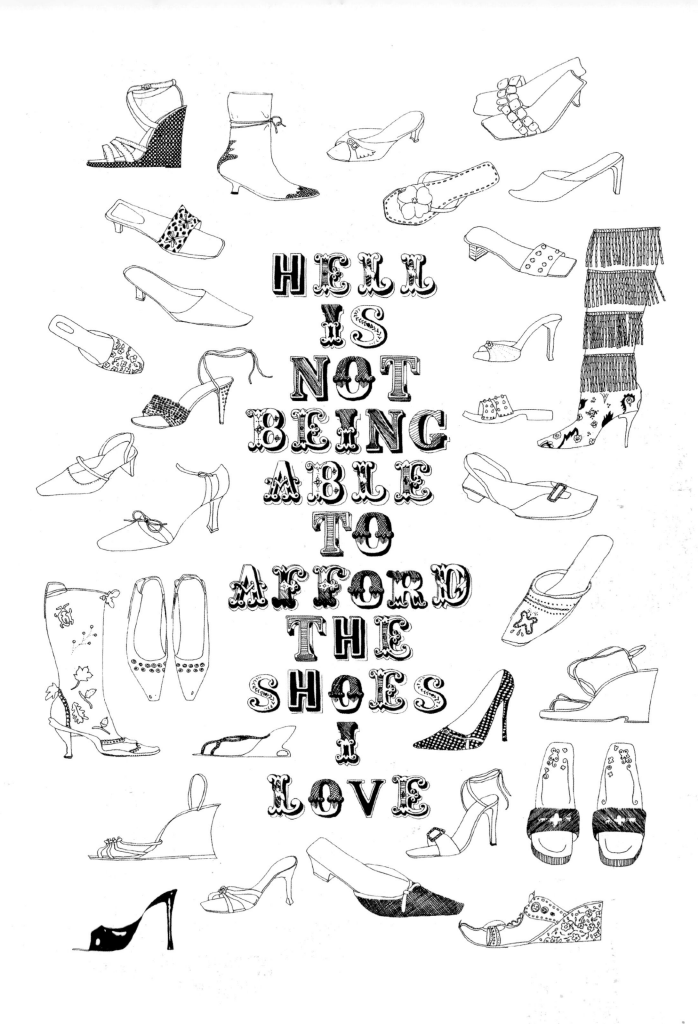

HELL IS NOT BEING ABLE TO AFFORD THE SHOES I LOVE

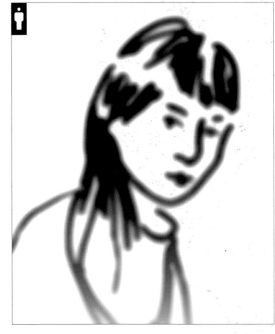

DEANNE CHEUK

DIGITAL ILLUSTRATOR DEANNE CHEUK WAS BORN IN PERTH, WESTERN AUSTRALIA, BUT HAS LIVED IN NEW YORK FOR THE PAST TWO YEARS. WITH A DEGREE IN GRAPHIC DESIGN, CHEUK SAYS SHE FELL INTO ILLUSTRATION WHEN SHE MOVED TO NEW YORK: WITHOUT A SCANNER, SHE NEEDED TO CREATE HER OWN IMAGES FROM SCRATCH AND NOW WORKS IN BOTH DISCIPLINES. SHE DESCRIBES THE STYLE OF HER ILLUSTRATION, WHICH COMBINES THE USE OF PENCIL AND COMPUTER, AS "DREAMING IN DIGITAL". SHE PRODUCES A PUBLICATION, WHICH SHE DESCRIBES AS A "GRAPHIC ZINE OF INSPIRATION", ENTITLED NEOMU (WWW.NEOMU.COM), IN WHICH SHE PUBLISHES THE WORK OF CREATIVES FROM AROUND THE WORLD. COMMERCIAL CLIENTS HAVE INCLUDED PRINTEMPS DEPARTMENT STORE IN PARIS FOR WHOM CHEUK CREATED FIVE WINDOW DISPLAYS, LEVI'S, ESPN AND FLAUNT, NYLON, GLAMOUR, IDN, BIG AND TOKION MAGAZINES.

BELOW/LEFT/TRANSMISSION02: UTOPIA BELOW/CENTRE/TRANSMISSION02: UTOPIA PART 2 BELOW/RIGHT/GEISHA TIGER
OPPOSITE/RAINBOW GIRLS

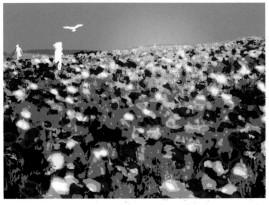

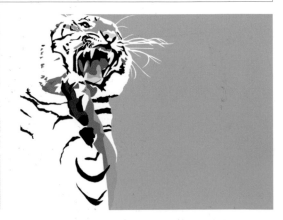

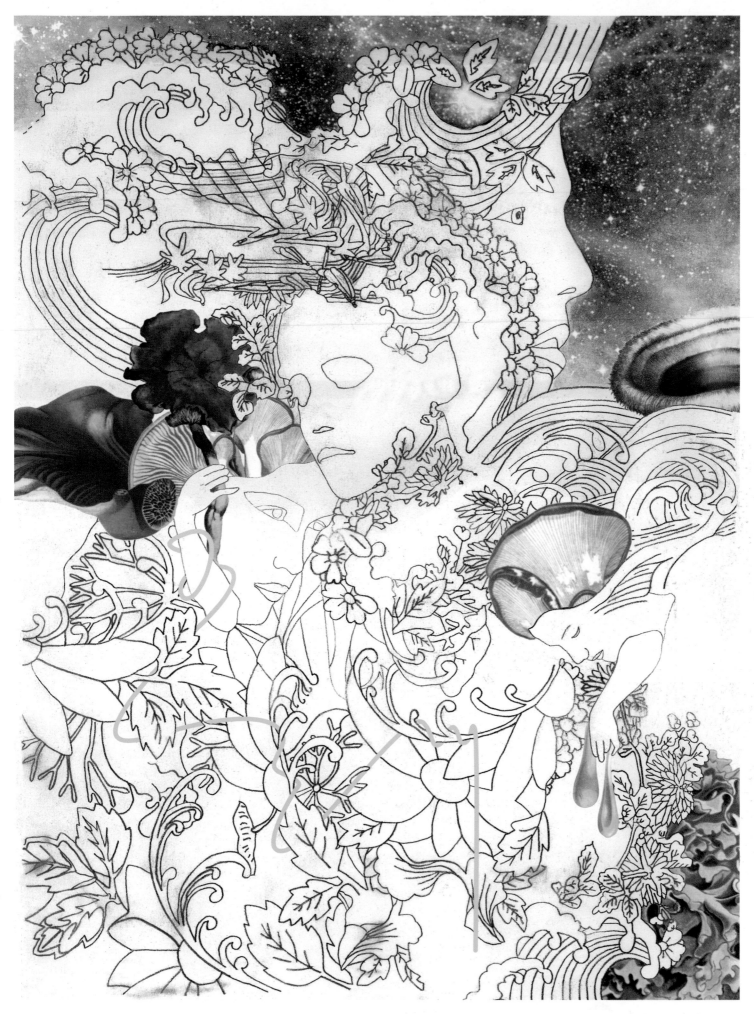

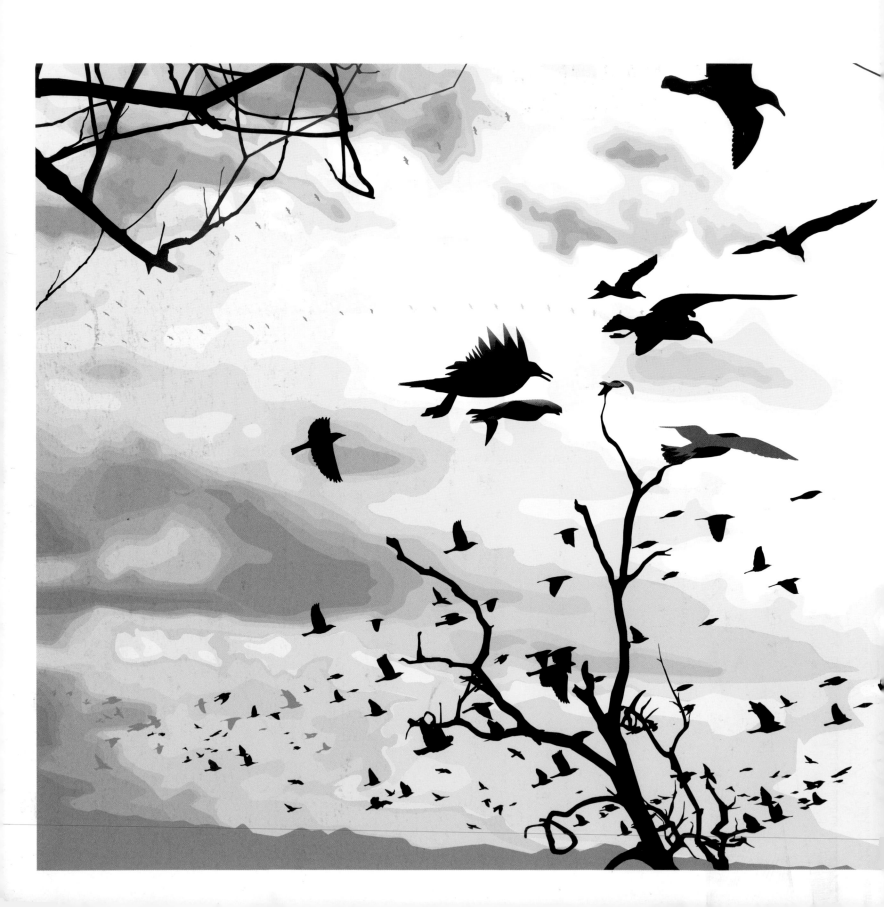

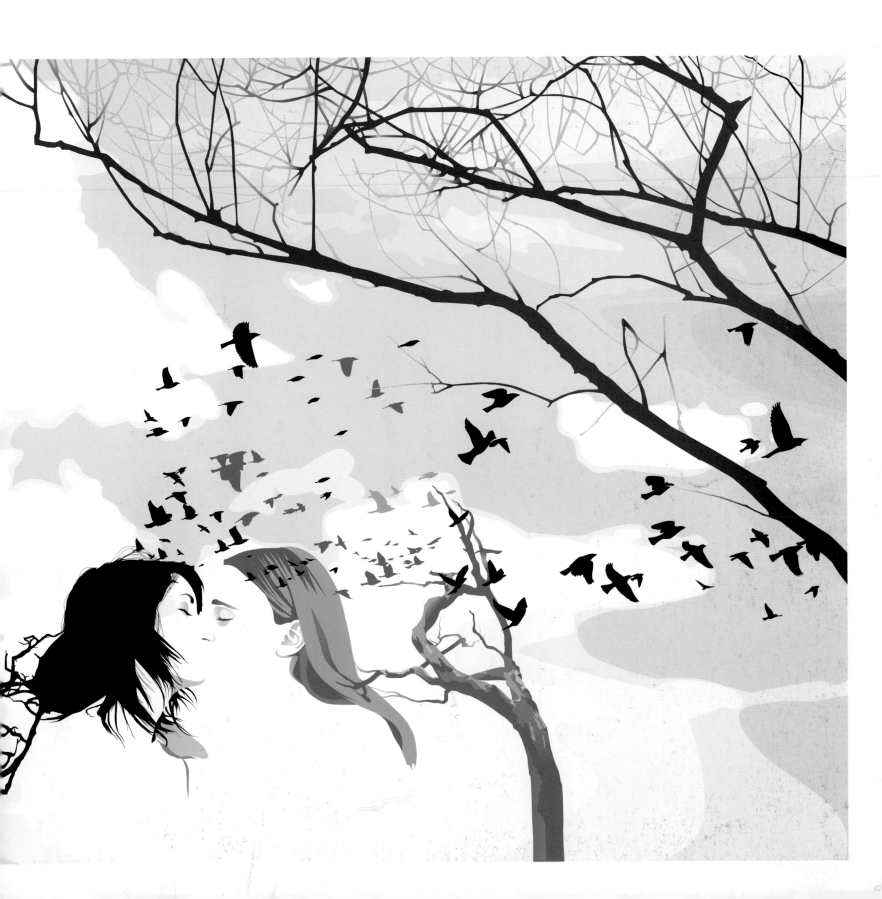

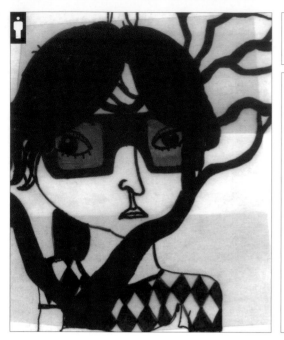

MAJA STEN

MAJA STEN WAS BORN IN SKANÖR IN SOUTHERN SWEDEN AND TODAY WORKS IN STOCKHOLM AS A FREELANCE ILLUSTRATOR. WHILE STUDYING PRODUCT DESIGN AT BECKMAN'S SCHOOL OF DESIGN IN STOCKHOLM, SHE REALIZED THAT SHE DID NOT ENJOY MODEL-MAKING BUT LOVED ILLUSTRATING THE PRODUCTS. SHE LEFT THE COURSE AND WAS ACCEPTED ON TO THE GRAPHIC DESIGN AND ILLUSTRATION COURSE AT KONSTFACK, STOCKHOLM. A MASTER OF ARTS DEGREE AT THE ROYAL COLLEGE OF ART IN LONDON FOLLOWED. SINCE GRADUATING IN 2002, STEN HAS CONTRIBUTED TO VARIOUS SWEDISH MAGAZINES INCLUDING MODERNA TIDER. SHE IS CURRENTLY CREATING HER OWN WEBSITE AND COLLABORATING ON PROJECTS WITH PRODUCT DESIGNERS. HER AIM IS TO "THINK LESS AND RELY MORE ON MY INTUITION".

BELOW/ILLUSTRATION INSPIRED BY THE SONG "HEY, THAT'S NO WAY TO SAY GOODBYE" BY LEONARD COHEN
OPPOSITE/TOP/WHERE EAGLES DARE OPPOSITE/BOTTOM/HOLLAND PARK POSSE

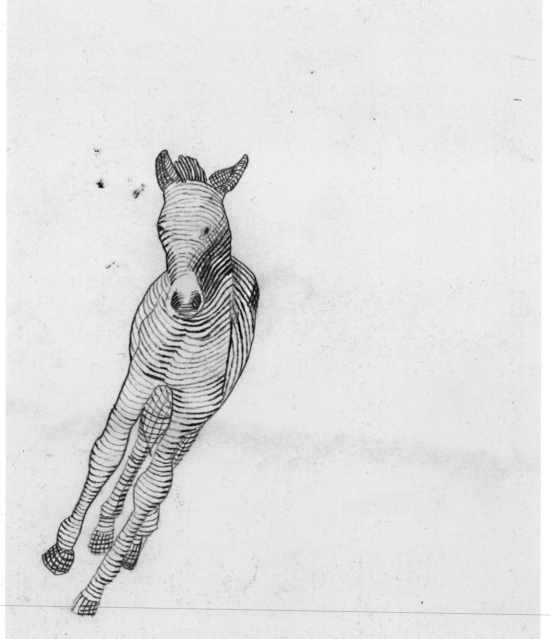

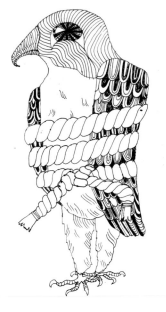

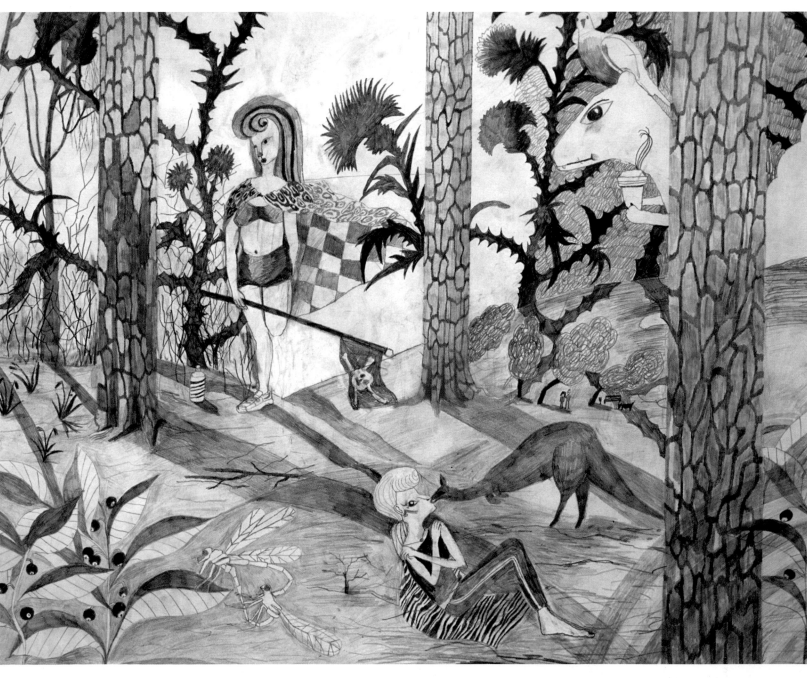

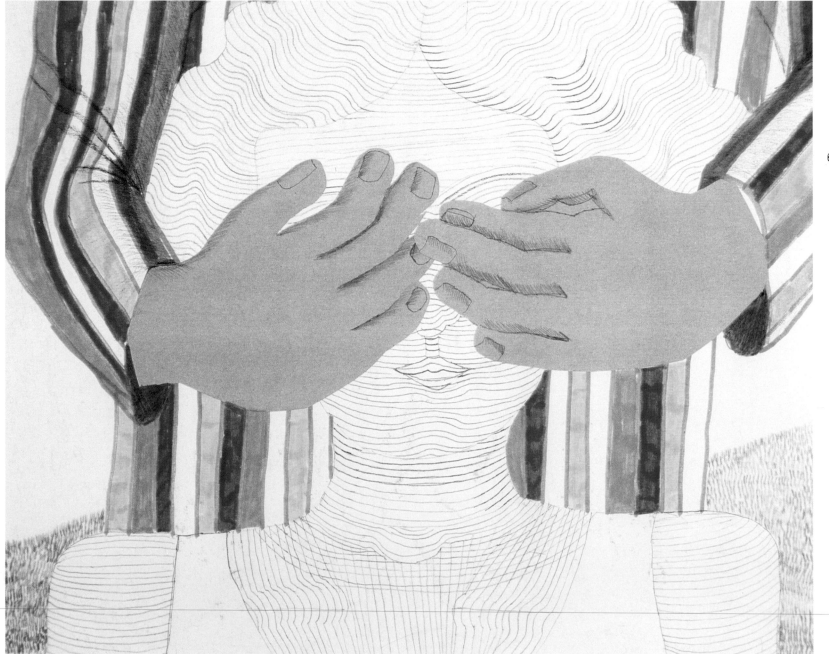

63

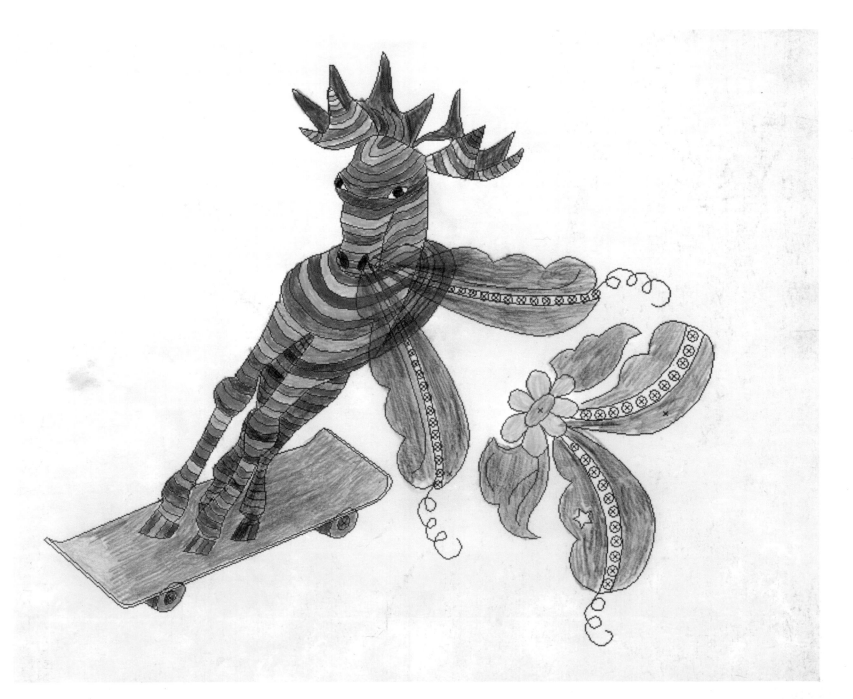

KENJI CHO

JAPANESE ART DIRECTOR AND DESIGNER KENJI CHO WAS BORN IN NAGANO PREFECTURE BUT HAS LIVED IN TOKYO'S HARAJYUKU FOR THE LAST DECADE. ALTHOUGH IT HAS BEEN HIS AMBITION SINCE CHILDHOOD TO CREATE IMAGES AS A PROFESSION, CHO HAD NO FORMAL ARTISTIC TRAINING. HE EMPLOYS BOTH PENCIL AND A COMPUTER – MORE SPECIFICALLY ADOBE ILLUSTRATOR SOFTWARE – AND HAS COMPLETED COMMISSIONS FOR MAGAZINES INCLUDING THE JAPANESE TITLE SELFISH, AS WELL AS DESIGNING AND ILLUSTRATING CD SLEEVES FOR SINGER/SONGWRITER HIKARU UTADA THROUGH THE TOSHIBA EMI RECORD LABEL. NON-COMMERCIAL PROJECTS INCLUDE CONTRIBUTING ILLUSTRATIONS TO SINGAPORE-BASED DESIGN AGENCY PHUNK STUDIO'S PUBLICATION TRANSMISSION02: UTOPIA WHICH, LAUNCHED IN APRIL 2002, SHOWCASED EXPERIMENTAL WORK FROM A HOST OF INTERNATIONAL CREATIVES. INSPIRED BY JAPANESE ART, CHO'S GREATEST AMBITION IS TO MAKE HIS OWN FEATURE FILM.

BELOW/A GIRL BESIDE A JAPANESE APRICOT TREE OPPOSITE/LEFT/SHIBUYA-CITY BOUGHT BY HONG KONG CAPITAL
OPPOSITE/RIGHT/HAZUKASIINA, DOKIDOKI, KUI! A GIRL IN THE GARDEN

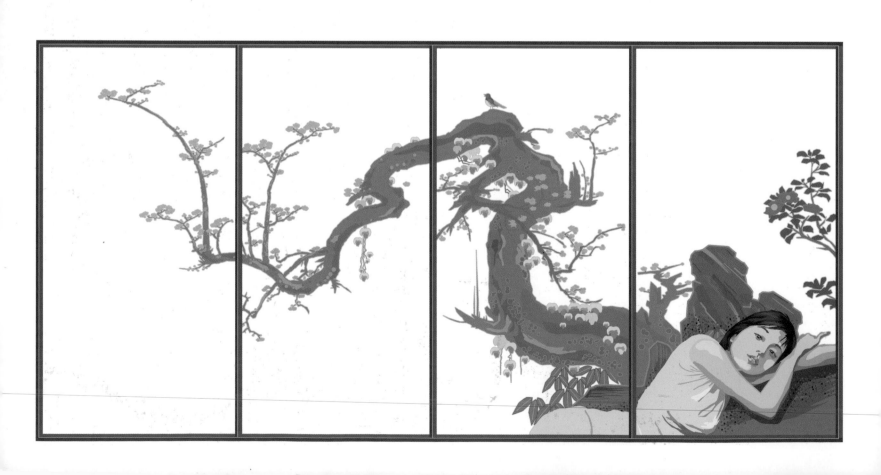

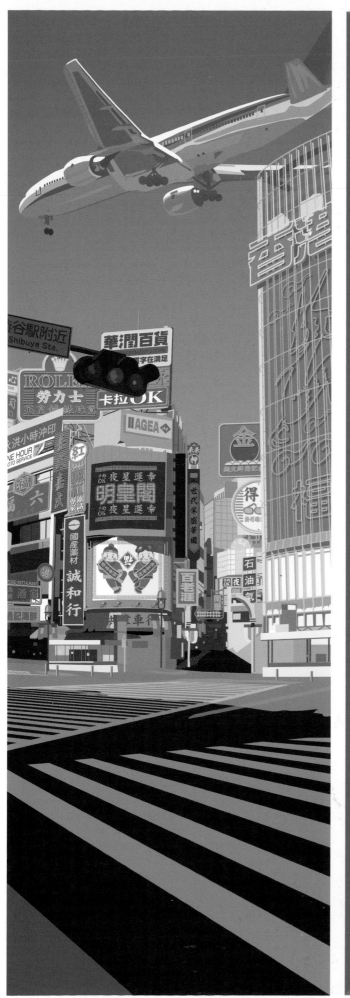

65

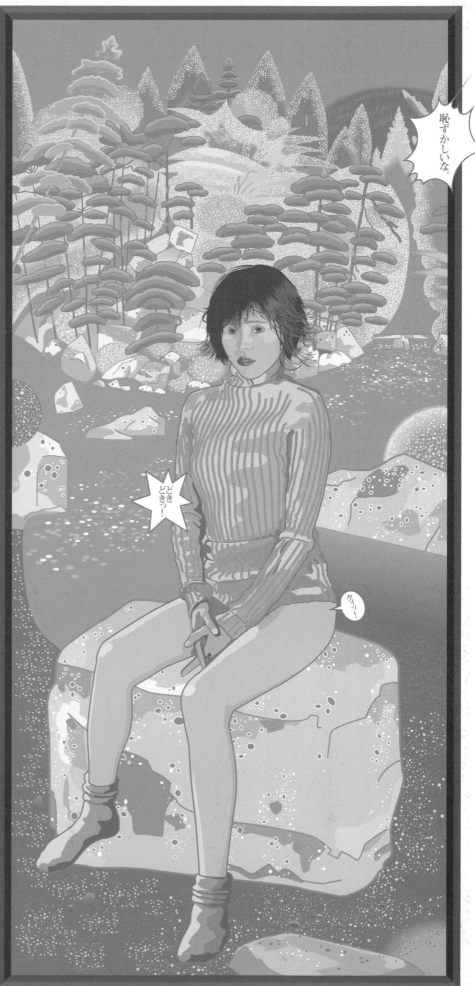

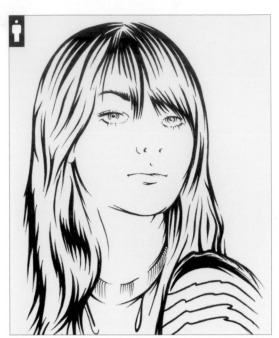

JO RATCLIFFE

"NOUVEAUDELLIC MIND COLLAGE" IS THE PHRASE JO RATCLIFFE EMPLOYS TO DESCRIBE HER STYLE OF ILLUSTRATION, CREATED USING PENS, PENCIL, PAINT, SPRAY PAINT AND A COMPUTER. RATCLIFFE HAS WORKED AS A FREELANCE ILLUSTRATOR SINCE GRADUATING FROM CENTRAL SAINT MARTINS COLLEGE, LONDON, WITH A BACHELOR OF ARTS DEGREE IN FINE ART, PRINT-MAKING AND PHOTOGRAPHY. HER WORK HAS APPEARED IN PUBLICATIONS SUCH AS THE NORWEGIAN MAGAZINE FJORDS, NYLON AND DAZED & CONFUSED, AND SHE ALSO CREATES ARTWORK FOR COMICS PUBLISHER STURGEON WHITE MOSS. RATCLIFFE SAYS HER MAIN INSPIRATION IS MUSIC, AND HER COMMERCIAL CLIENTS INCLUDE MUSIC LABELS SONY AND V2.

BELOW/LEFT/TOP/FLOWER ARRANGEMENT BELOW/LEFT/BOTTOM/BUTTERFLY BELOW/RIGHT/NARCISSUS
OPPOSITE/TOO MUCH CHOICE

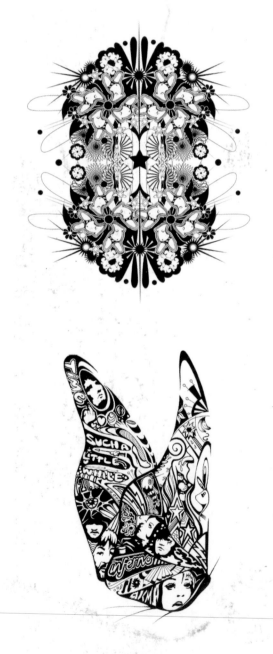

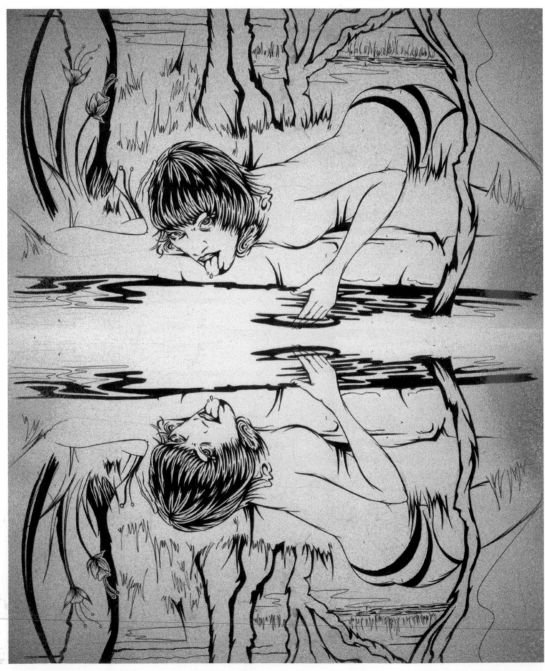

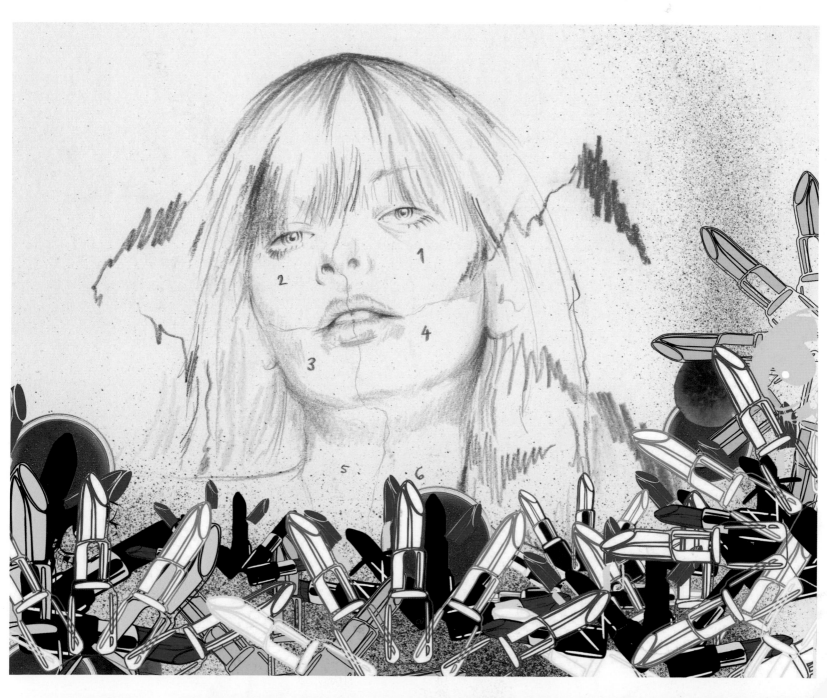

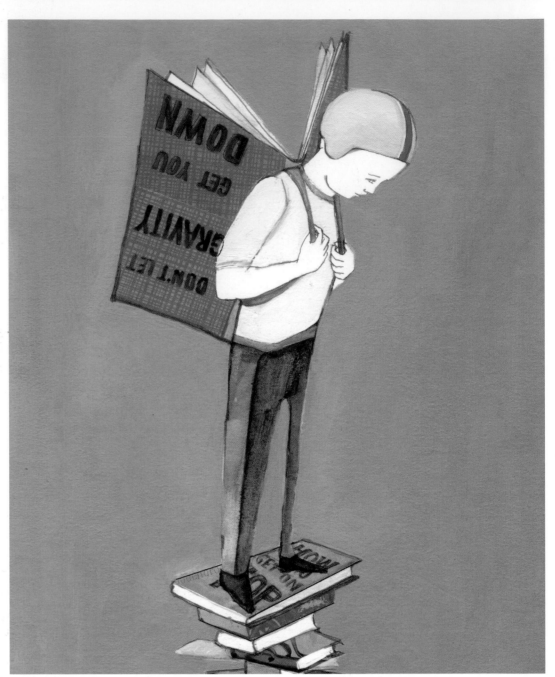

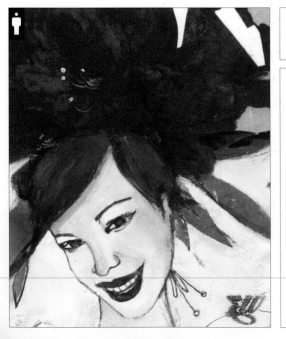

EDWINA WHITE

SYDNEY-BORN FREELANCE ILLUSTRATOR EDWINA WHITE IS CURRENTLY BASED IN NEW YORK. AFTER GRADUATING IN 1993 WITH A DEGREE FROM THE UNIVERSITY OF TECHNOLOGY IN SYDNEY, WHICH INCORPORATED A TERM OF ILLUSTRATION AT THE UNIVERSITY OF BRIGHTON IN THE UK, WHITE SPENT FIVE YEARS TEACHING CLASSES IN DESIGN AND IMAGE-MAKING. SHE WORKS PRIMARILY WITH UNIQUE TOOLS SUCH AS "TEA, FLORIST'S WIRE, TAPE OF ALL SORTS, SUEDE AND WOOD ALONGSIDE THE MORE USUAL PENCIL, INK AND ACRYLIC", AND HAS ONLY RECENTLY BOUGHT A COMPUTER, WHICH SHE MAINTAINS IS FOR SCANNING AND SENDING WORK ONLY. EDITORIAL CLIENTS INCLUDE JAPANESE VOGUE, US HARPER'S BAZAAR, THE NEW YORK TIMES, THE WALL STREET JOURNAL AND FLAUNT MAGAZINE. WHITE HAS ALSO COMPLETED WORK FOR VARIOUS DESIGN AND AD AGENCIES INCLUDING BAM SSB IN SYDNEY.

ABOVE/THE SELF-HELP BOOKPILE
OPPOSITE/TOP/NINE-TO-FIVE (52 PICK UP) OPPOSITE/BOTTOM/A ROYAL FLUSH (52 PICK UP)

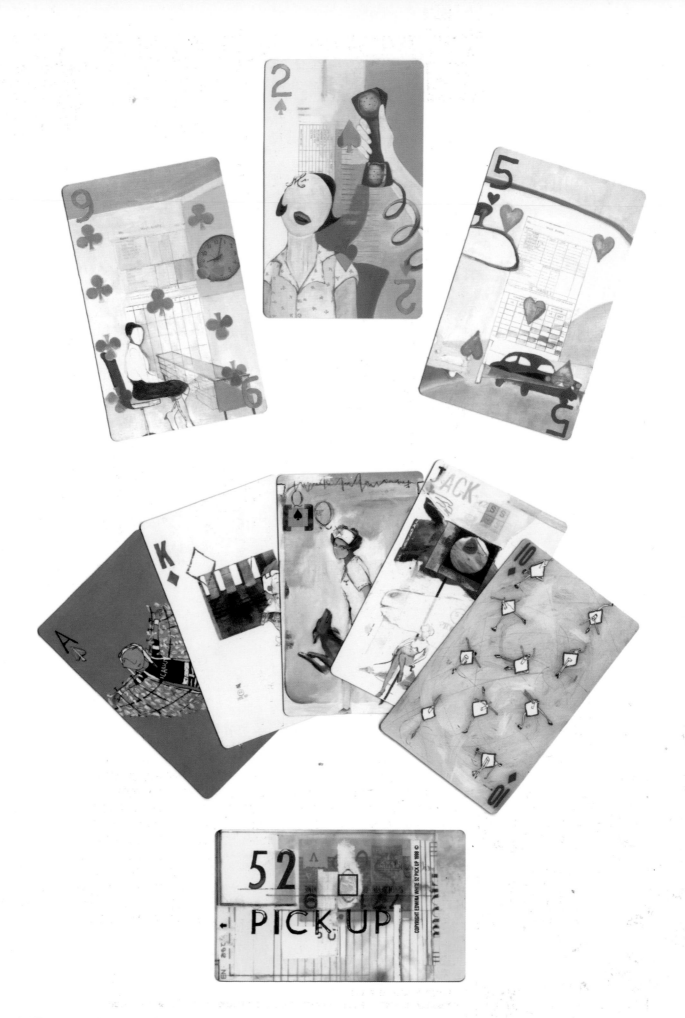

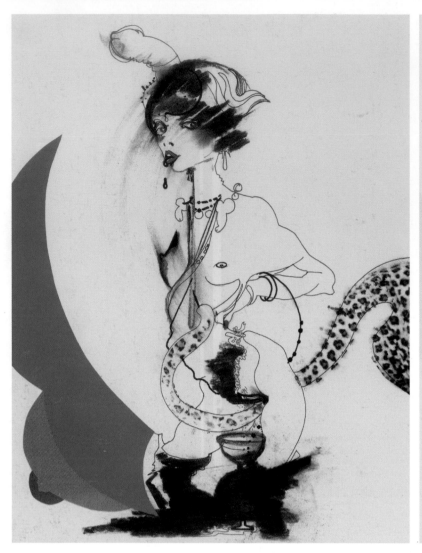

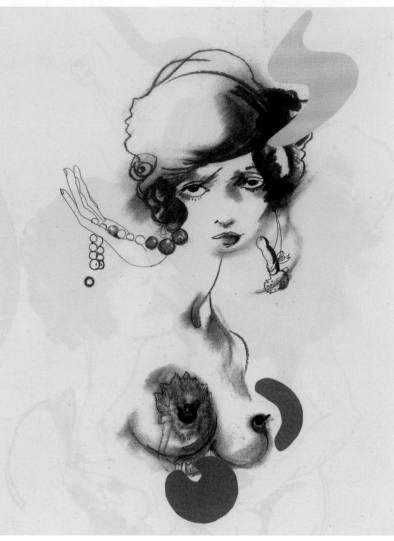

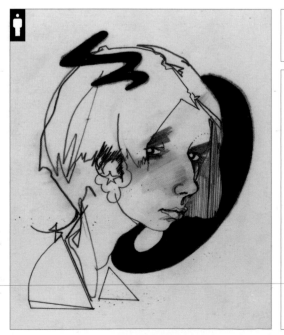

JULIE VERHOEVEN

INSPIRED BY "HUMAN FORM, CHARACTER AND BEHAVIOUR, AS WELL AS ALL FORMS OF POPULAR CULTURE AND ESPECIALLY MUSIC", LONDON-BASED JULIE VERHOEVEN USES PEN, PENCIL, PAINTBRUSH AND PHOTOCOPIER TO CREATE HER INTRICATE AND HUGELY DETAILED ILLUSTRATIONS. VERHOEVEN, WHO STRIVES TO KEEP HER WORK "FOREVER MOVING AND DIFFICULT TO DESCRIBE", HAS CONTRIBUTED TO NUMEROUS STYLE MAGAZINES, AND HAS ALSO BEEN DESIGN ASSISTANT TO MARTINE SITBON IN PARIS. MORE RECENT WORK INCLUDES HIGH-PROFILE COMMISSIONS FOR LOUIS VUITTON, CACHAREL, GIBO AND UK NUDE RECORDS ACT GLOSS. ELABORATING ON THE PAINSTAKING METHOD SHE EMPLOYS TO CREATE HER ARTWORK, VERHOEVEN EXPLAINS: "I DO ALL MY SKETCHES INDIVIDUALLY AND THEN START TO PIECE THEM TOGETHER BY PHOTOCOPYING THEM AT THE APPROPRIATE SIZE. I GENERALLY DO IT THREE TIMES AND THEN I PIN IT UP ON THE WALL AND LOOK AT IT AND DECIDE TO CHANGE THINGS. IT'S ALL VERY PRIMITIVE AND LABORIOUS."

ABOVE & OPPOSITE RIGHT/THE LADY IS A TRAMP OPPOSITE/LEFT/NUMERO MAGAZINE PERFUME ILLUSTRATION

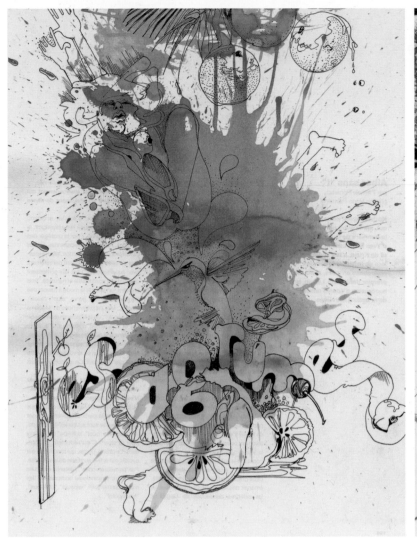

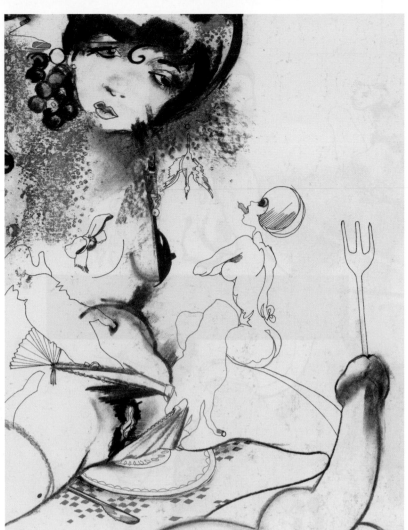

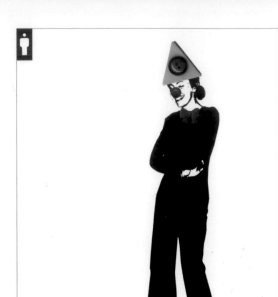

MARIE O'CONNOR

"I WORK MOSTLY AS A DIRECT RESPONSE TO FOUND MATERIALS AND SURFACES, OR WITH VARIOUS BITS THAT WOULD HOLD LITTLE VALUE FOR MOST PEOPLE", EXPLAINS SCOTTISH IMAGE-MAKER AND DESIGNER MARIE O'CONNOR. SHE GRADUATED WITH A DEGREE IN TEXTILES FROM GLASGOW SCHOOL OF ART IN 1999, AND NOW CREATES UNIQUE LO-FI, TACTILE PIECES BY COMBINING FOUND OBJECTS, INCLUDING PIECES FROM COMPUTER KEYBOARDS AND CIRCUIT BOARDS, WITH FABRIC, PHOTOCOPIED GRAPHICS AND DIFFERENT PAPERS. O'CONNOR'S ILLUSTRATIONS HAVE APPEARED IN SHISEIDO'S MAGAZINE HANATSUBAKI, TANK, MINED AND THE DAZED & CONFUSED ANNUAL, AND SHE HAS ALSO CREATED PROMOTIONAL ARTWORK FOR LEVI'S ENGINEERED JEANS. HER AMBITIONS FOR THE FUTURE ARE: "TO WORK ON AS MANY SELF-INITIATED PROJECTS AS POSSIBLE, COLLABORATE WITH OTHERS WHOSE WORK I FIND EXCITING AND CHALLENGING AND LEARN MORE TECHNIQUES AND SKILLS THAT CAN BE ABUSED."

BELOW/UNTITLED, CREATED IN COLLABORATION WITH CAROLINE VOGEL
OPPOSITE/TOP/THREAD CAREFULLY, MINED OPPOSITE/BOTTOM/LEFT & RIGHT/LEVI'S ENGINEERED JEANS PRESS PACK

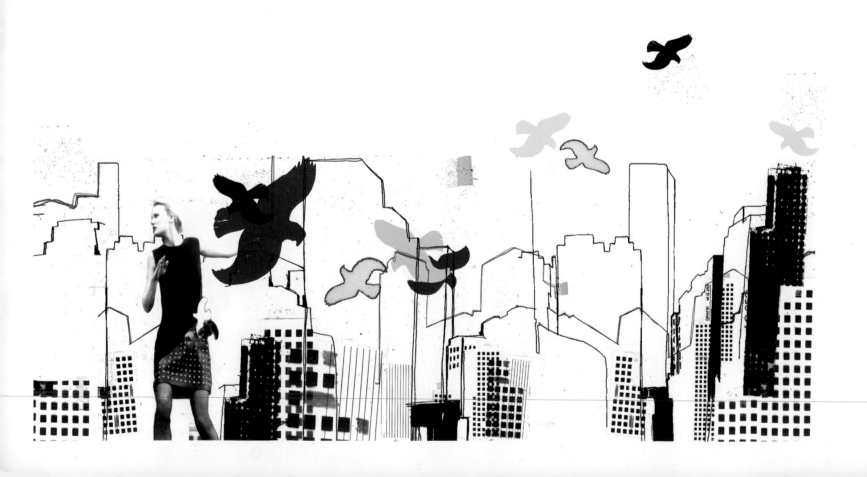

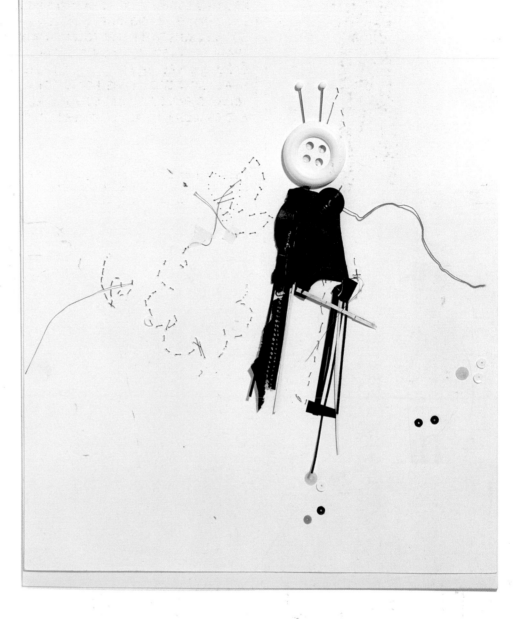

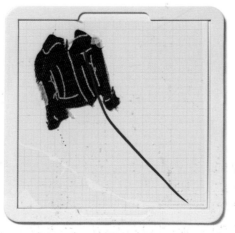

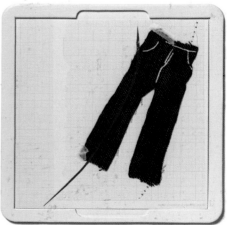

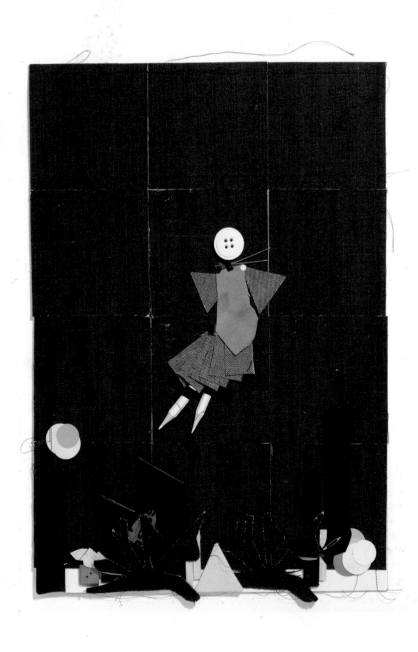

74

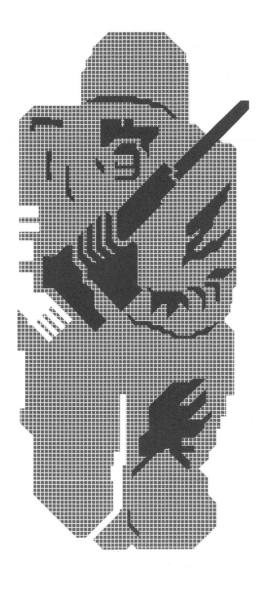

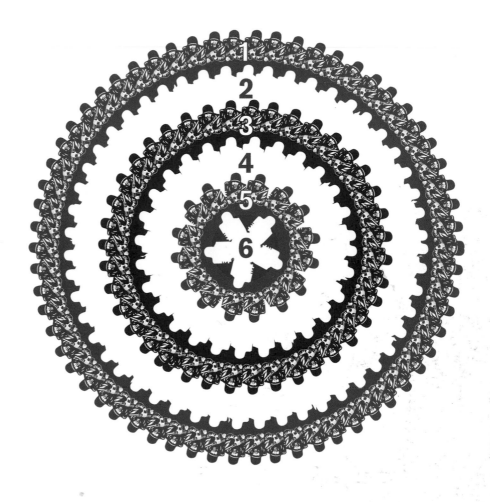

MATT DUCKETT

IMAGE-MAKER AND DESIGNER MATT DUCKETT WAS BORN IN BANGOR, NORTH WALES BUT IS TODAY BASED IN LONDON. HE RECENTLY GRADUATED FROM THE UNIVERSITY OF BRIGHTON WITH A DEGREE IN GRAPHIC DESIGN, AND HIS WORK TO DATE HAS BEEN EXPERIMENTAL OR CREATED IN ANSWER TO COLLEGE BRIEFS. HE USES PEN AND PENCIL WHEN ILLUSTRATING, SAVING THE COMPUTER JUST FOR THE FINISHING TOUCHES AND COLOURING, AND DESCRIBES HIS STYLE AS "SIMPLE". DUCKETT IS INSPIRED BY MILITARY EPHEMERA AND CHILDREN'S GAMES. HE PRODUCED THE FOUR TARGETS ON PAGE 76, WHICH WERE ORIGINALLY CREATED TO A LIFE-SIZE SCALE, FOR HIS DEGREE SHOW BUT WAS THEN COMMISSIONED BY CREATIVE REVIEW MAGAZINE TO PRODUCE A FOURTH, LARGER TARGET AS A POSTER FOR THEIR SEPTEMBER 2002 ISSUE.

LEFT/SIMPLIFIED SOLDIER RIGHT/TARGET

MATT DUCKETT

TOP/LEFT/ANIMAL TARGET
TOP/RIGHT/ASSORTED BODY ORGAN TARGET
BOTTOM/LEFT/DEVELOPING FOETUS TARGET
BOTTOM/RIGHT/VEGETARIAN TARGET
OPPOSITE/CENTREFOLD TARGET

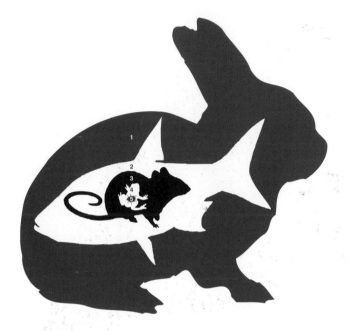

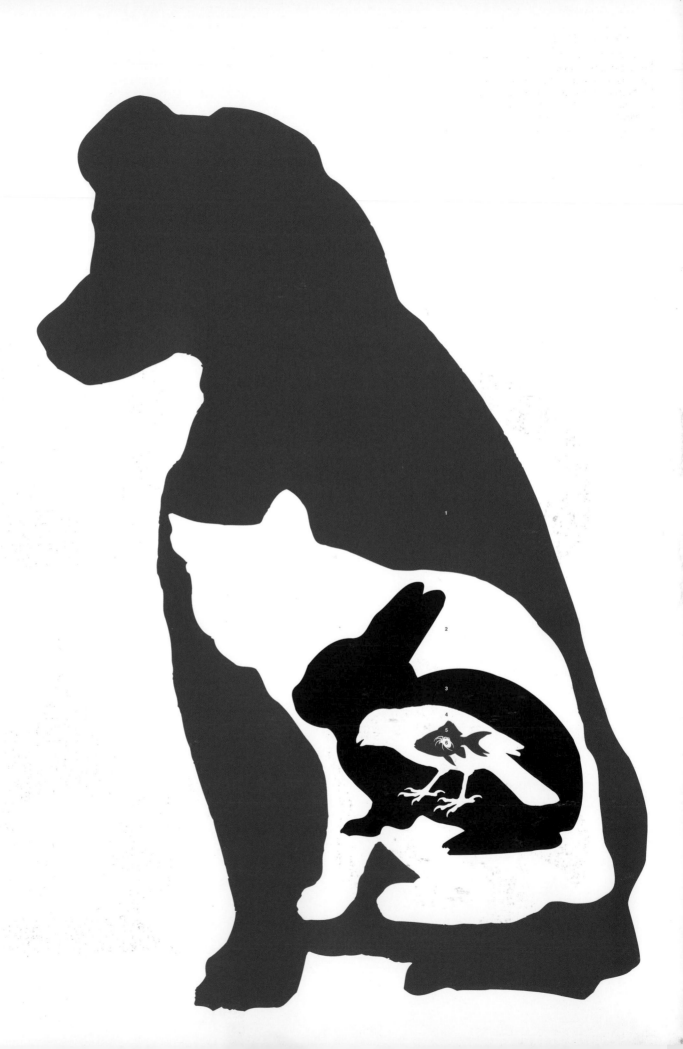

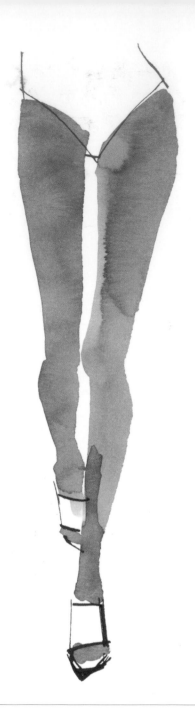

LOVISA BURFITT

AUSTRALIAN ARTIST, ILLUSTRATOR AND FASHION DESIGNER LOVISA BURFITT WAS BORN IN SYDNEY BUT NOW LIVES IN PARIS. SHE GRADUATED IN 1997 WITH A DEGREE FROM BECKMAN'S SCHOOL OF FASHION IN STOCKHOLM, AND FROM HER BASE IN PARIS IS CURRENTLY STUDYING FOR A MASTER OF ARTS AT STOCKHOLM'S ROYAL ACADEMY OF FINE ARTS. BURFITT'S COMMISSIONS TO DATE INCLUDE WORK FOR HARVEY NICHOLS MAGAZINE, VOGUE UK, ELLE AUSTRALIA AND HIGH-STREET LABEL H&M. SHE ALSO OCCUPIES HERSELF BY PLASTERING CITY STREETS WITH HER EXPERIMENTAL POSTERS. A TRADITIONAL PRACTITIONER, BURFITT WORKS MAINLY WITH PEN AND INK. SHE DESCRIBES HER ILLUSTRATIONS AS "VERY FAST AND RESTLESS".

ABOVE/LEFT/TOP/FASHIONABLE LEGS ABOVE/LEFT/BOTTOM/WALKING BOOTS ABOVE/RIGHT/UNTITLED
OPPOSITE/LEFT/ROMANTIC LEGS OPPOSITE/RIGHT/YSL RIVE GAUCHE SHOES

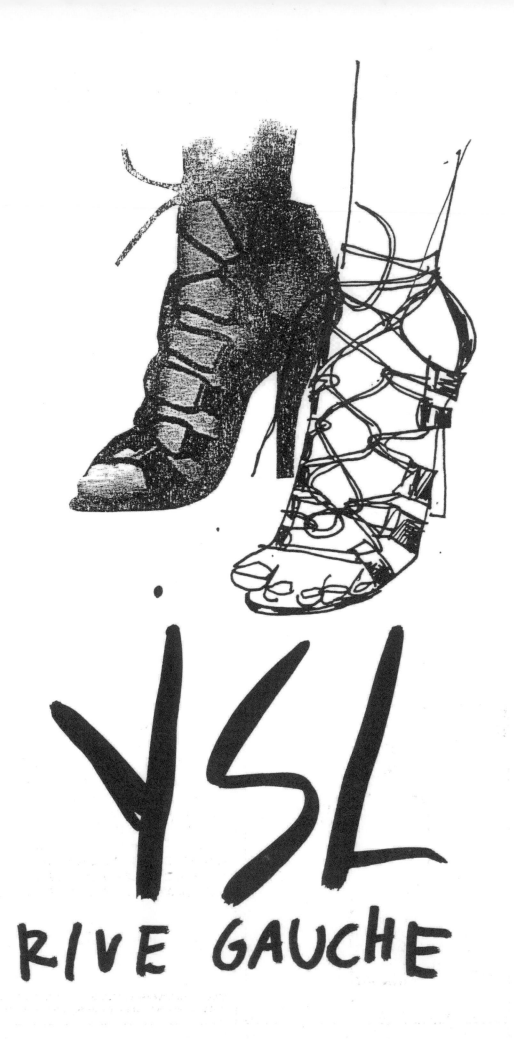

YSL
RIVE GAUCHE

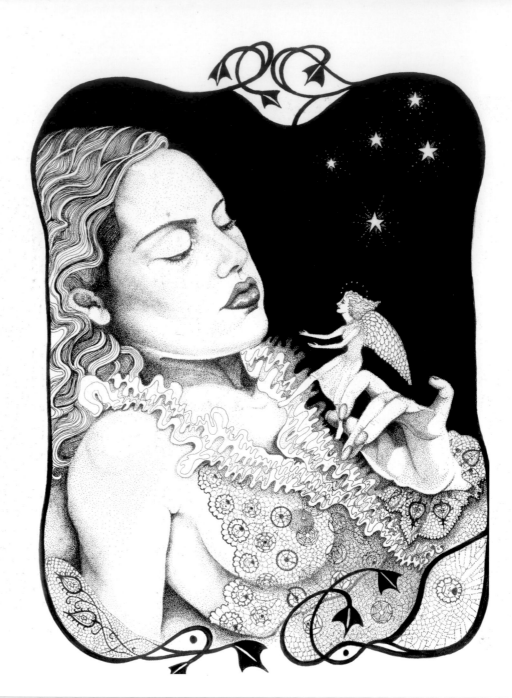

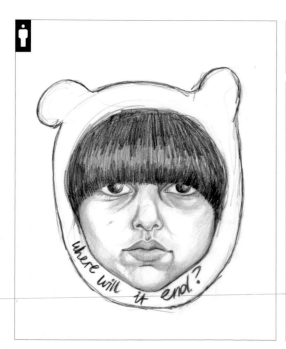

IZZIE KLINGELS

SINCE GRADUATING WITH A BACHELOR OF ARTS DEGREE IN FINE ART FROM THE CHELSEA SCHOOL OF ART AND DESIGN IN LONDON, IZZIE KLINGELS HAS DIVIDED HER TIME BETWEEN ART DIRECTION, ILLUSTRATION, FILM AND VIDEO. KLINGELS COMBINES THE USE OF PEN, INK AND PENCIL TO CREATE HER ILLUSTRATIONS WHICH SHE DESCRIBES AS "QUITE FEMININE, WITH A DARK UNDERCURRENT". COMMERCIAL PROJECTS TO DATE INCLUDE EDITORIAL COMMISSIONS FOR DAZED & CONFUSED AND THE CO-DIRECTION OF A LIVE VIDEO SHOW FOR DANCE/ROCK ACT DEATH IN VEGAS'S 1999 TOUR. IN 2001 SHE COLLABORATED WITH RACHEL THOMAS AND LIZZIE FINN ON OASIS'S "SHE IS LOVE" POP PROMO. KLINGELS IS INSPIRED BY ARTIST MIKE KELLEY, SEMINAL MANCHESTER BAND JOY DIVISION AND AUTHOR PAUL AUSTER. SHE DEDICATES MUCH OF HER SPARE TIME TO ART DIRECTING HEY LADIES, A FANZINE SHOWCASING THE WORK OF THE WRITERS, ILLUSTRATORS AND PHOTOGRAPHERS WHO MAKE UP THE ALL-FEMALE COLLECTIVE OF THE SAME NAME.

ABOVE/IN DECADENCE WE TRUST
OPPOSITE/LEFT/BLOOD AND FIRE OPPOSITE/RIGHT/IT'S NO GOOD

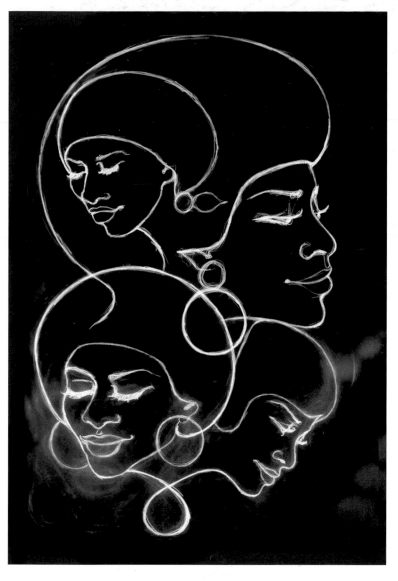

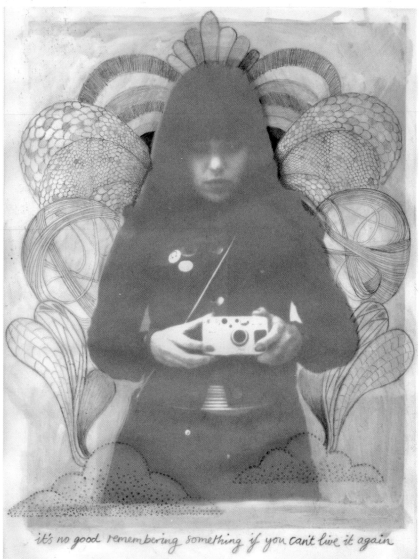

it's no good remembering something if you can't live it again

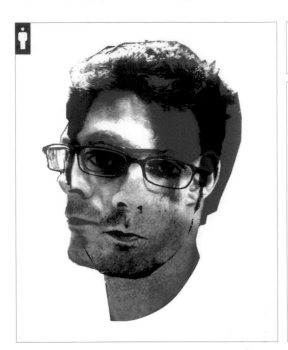

OTTO

"MY GRAPHIC INFLUENCES ARE VARIED BUT I PREDOMINANTLY DRAW ON THE EASTERN EUROPEAN CONSTRUCTIVISTS", EXPLAINS GERMAN GRAPHIC ARTIST OTTO. HE EMPLOYS PAPER, SCISSORS, PEN, PHOTOCOPIER, DIGITAL CAMERA AND COMPUTER TO PRODUCE HIS UNIQUE SCREENPRINTED ILLUSTRATIONS. SINCE GRADUATING WITH A MASTER OF ARTS DEGREE FROM KINGSTON UNIVERSITY IN THE UK, OTTO HAS DEDICATED MUCH OF HIS TIME TO CREATING ARTIST'S BOOKS: "I NOW HAVE A COLLECTION OF ABOUT 10 BOOKS. THEY CONTAIN GRAPHIC NARRATIVES ABOUT ISSUES LIKE CONSUMERISM, TIME AND SPACE, MYTHS AND WORK. I PRINT AND BIND THE BOOKS MYSELF, USUALLY IN SMALL EDITIONS, AND THEN SELL THEM AT ARTIST'S BOOK FAIRS." COMMERCIAL COMMISSIONS TO DATE INCLUDE EDITORIAL ILLUSTRATION FOR THE LIKES OF THE ECONOMIST, LE MONDE INTERACTIF AND THE INDEPENDENT ON SATURDAY MAGAZINE.

BELOW/A BAS BIG BROTHER! OPPOSITE/TOP/LEFT/TIME MACHINES / DNA-BASED COMPUTING
OPPOSITE/TOP/RIGHT/UNKNOWN / ORGANIC MACHINES OF THE FUTURE
OPPOSITE/BOTTOM/SERIAL ENTREPRENEURS, A SURVEY OF FINANCE IN CENTRAL EUROPE

84

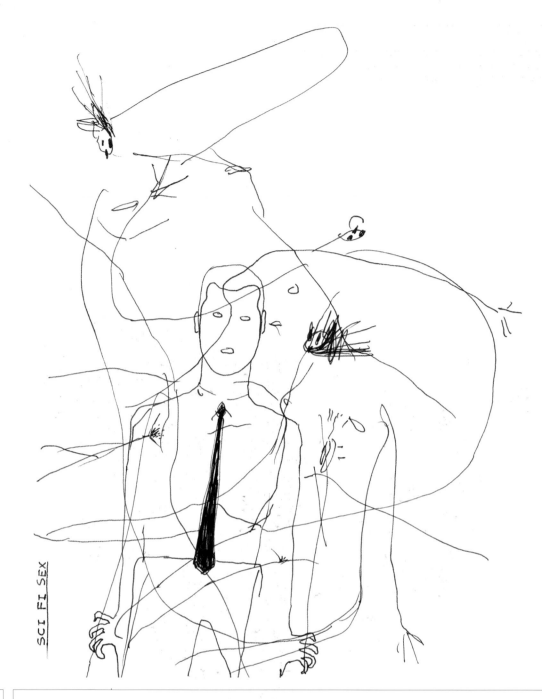

SCI FI SEX

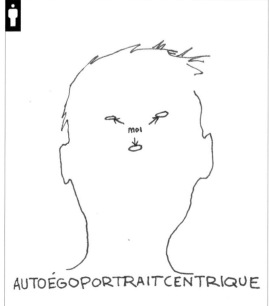

AUTOÉGOPORTRAITCENTRIQUE

SEB JARNOT

FRENCH ILLUSTRATOR AND DESIGNER SEB JARNOT HAS ALWAYS LOVED DRAWING. SO MUCH SO IN FACT THAT THE THOUGHT OF BEING ABLE TO APPLY THIS PASSION IN HIS EVERYDAY LIFE AND WORK HAS BEEN "AN OBSESSIVE IDEA" SINCE CHILDHOOD. JARNOT GRADUATED FROM THE ECOLE BRASSART IN TOURS WITH A DEGREE IN GRAPHIC DESIGN IN 1991. IT WAS SEVERAL YEARS LATER THAT HE DEVELOPED HIS UNIQUE STYLE, WHICH HE DESCRIBES AS "FREE AND FIGURATIVE". BASED IN NÎMES IN THE SOUTH OF FRANCE, WHERE HE HAS LIVED FOR THE PAST NINE YEARS, JARNOT HAS WORKED ON COMMISSIONS FOR NIKE AND FOR FRENCH ARTISTS ERIC MORAND AND LAURENT GARNIER ON RECORD LABEL F COMMUNICATIONS. HE ALSO DEDICATES TIME TO CHARITABLE ASSOCIATIONS.

ABOVE/SCI-FI SEX

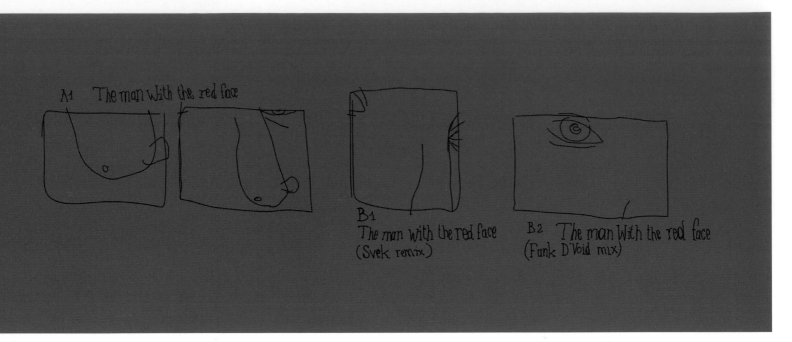

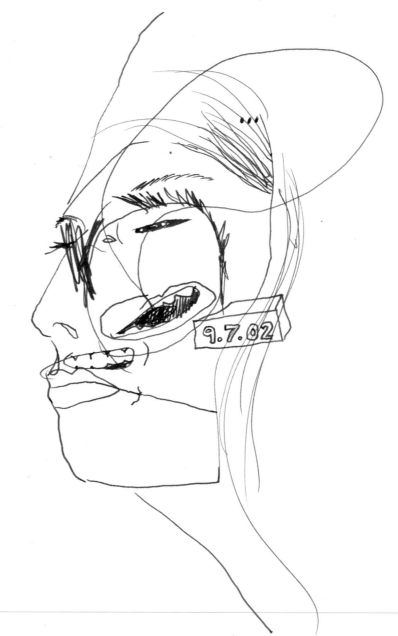

SEB JARNOT

RIGHT/UNTITLED
ABOVE/THE MAN WITH THE RED FACE EP DETAIL - LAURENT GARNIER
OPPOSITE/THE MAN WITH THE RED FACE EP - LAURENT GARNIER

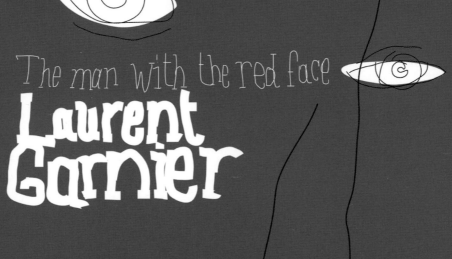

The man with the red face

Laurent Garnier

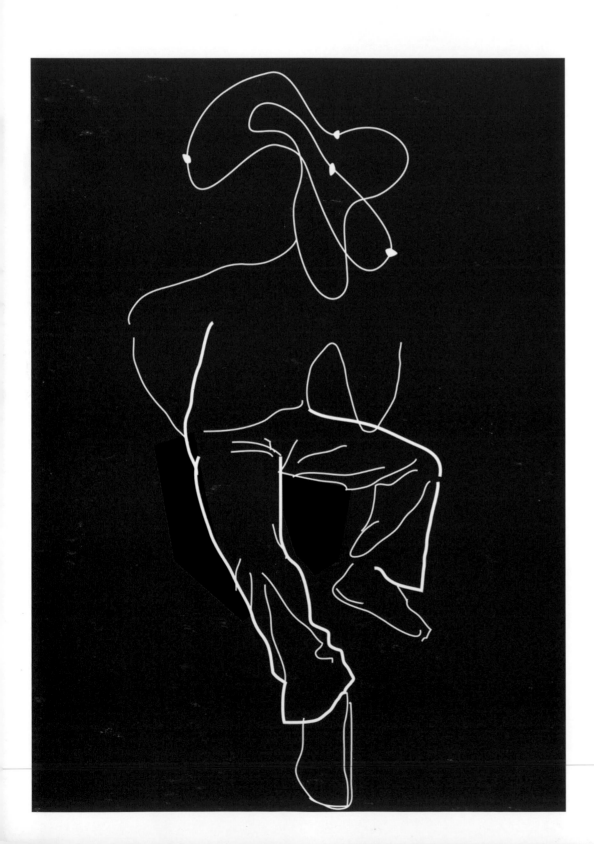

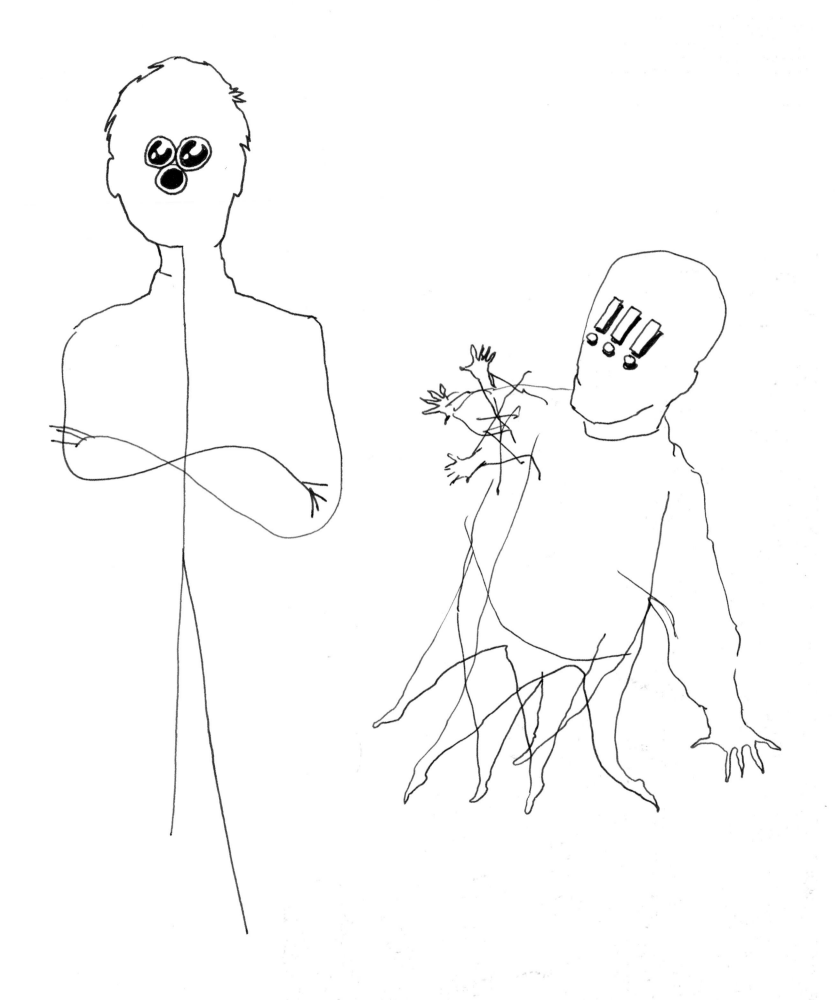

89

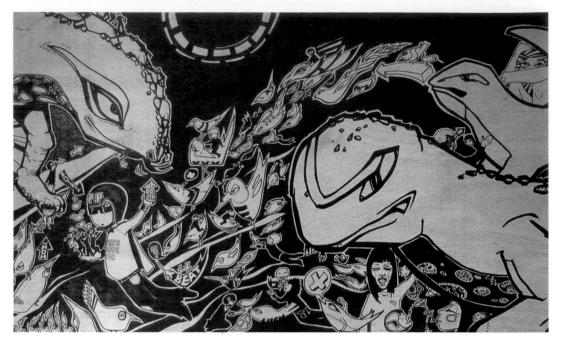

LUCY MCLAUCHLAN

BRITISH FREELANCE ILLUSTRATOR LUCY MCLAUCHLAN DIVIDES HER TIME BETWEEN COMMER-
CIAL COMMISSIONS FOR CLIENTS IN ADVERTISING, PUBLISHING AND RETAIL, AND EXPERIMENTAL
ART PROJECTS WHICH SHE CREATES AS PART OF THE MULTI-DISCIPLINARY ART COLLECTIVE
BEAT13. HER RAW, GRAFFITI-STYLE ILLUSTRATIONS, DRAWN USING MARKER PEN ON PLYWOOD,
HAVE WON HER CAMPAIGNS FOR CARHARTT AND, MORE RECENTLY, JAPANESE FASHION
LABEL LOWRY'S FARM. BASED IN LONDON, WHERE SHE HAS LIVED SINCE GRADUATING FROM
LIVERPOOL ART SCHOOL WITH A DEGREE IN GRAPHIC ARTS IN 1999, MCLAUCHLAN PURSUES
HER BEAT13 ACTIVITIES "AS AN ESCAPE FROM COMMERCIAL WORK". SHE FORMED THE
COLLECTIVE IN 1999 WITH MATT WATKINS, AND THEIR EXHIBITIONS AND WEBSITE LED TO THE
OPENING OF A SMALL GALLERY/SHOP IN BIRMINGHAM. "THE INTENTION IS TO DISPLAY GOOD
WORK FROM ALL THE TALENT AROUND US AT THE MOMENT AS WELL AS TO HAVE A SPACE
FOR OUR OWN PROJECTS."

ABOVE/REPTILES, BERLIN PEEPS
OPPOSITE/TOP/MUTE, BERLIN PEEPS OPPOSITE/CENTRE/DETAIL OF BERLIN PEEPS OPPOSITE/BOTTOM/AND, BERLIN PEEPS

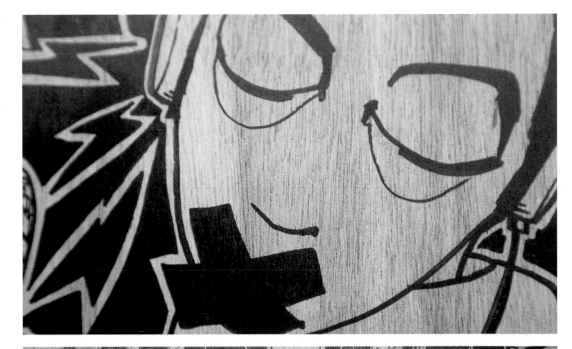

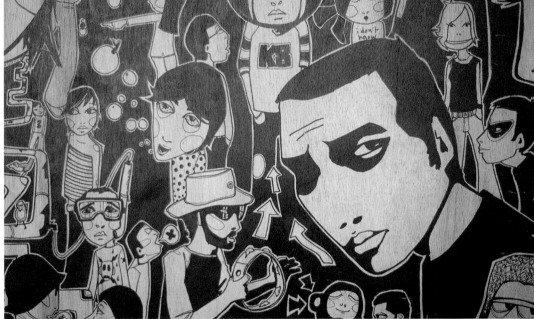

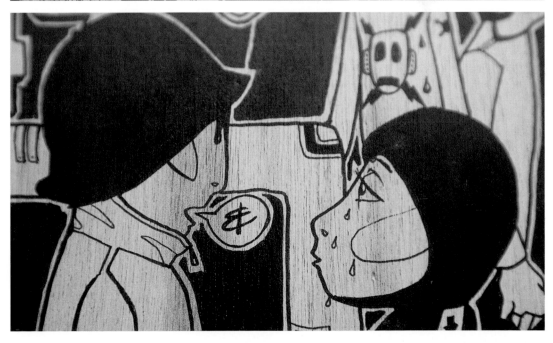

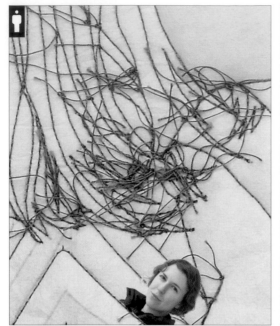

LIZZIE FINN

LONDON-BORN LIZZIE FINN WORKS ACROSS ILLUSTRATION, GRAPHIC DESIGN, ART DIRECTION AND MOVING-IMAGE DESIGN. COMBINING THE USE OF SEWING-MACHINE EMBROIDERY, PHOTOGRAPHY AND PEN, FINN'S ILLUSTRATIONS, WHICH SHE DESCRIBES AS "HAND-MADE IN A DIGITAL SORT OF WAY AND GRAPHIC IN A CRAFTY SORT OF WAY", ARE PUT TOGETHER ON A MAC. FIRST DRAWN TO ILLUSTRATION AT CENTRAL SAINT MARTINS COLLEGE OF ART AND DESIGN AFTER DEVELOPING A FASCINATION FOR FASHION ILLUSTRATION OF THE 1950S, 60S AND 70S, FINN IS TODAY INSPIRED BY MAPS, VIKING STATIONERY CATALOGUES, 1970S WOMEN'S MAGAZINES, HABERDASHERIES, TYPE SPECIMEN SHEETS, ANTIQUE SIGNAGE AND OLD ILLUSTRATION AND GRAPHIC DESIGN YEARBOOKS. SHE ALSO COLLECTS SEWING AND CRAFT BOOKS "FOR THEIR PHOTOS, LAYOUT AND DIAGRAMS" AND VARIOUS PRINTED EPHEMERA FOR REFERENCE. CLIENTS HAVE INCLUDED SILAS, DAZED & CONFUSED, JAPANESE AND BRITISH VOGUE AND BANDS MOLOKO AND OASIS.

BELOW/IMAGE FOR BOOK ENTITLED 150 B&T OPPOSITE/IMAGE FOR RELAX MAGAZINE, TOKYO

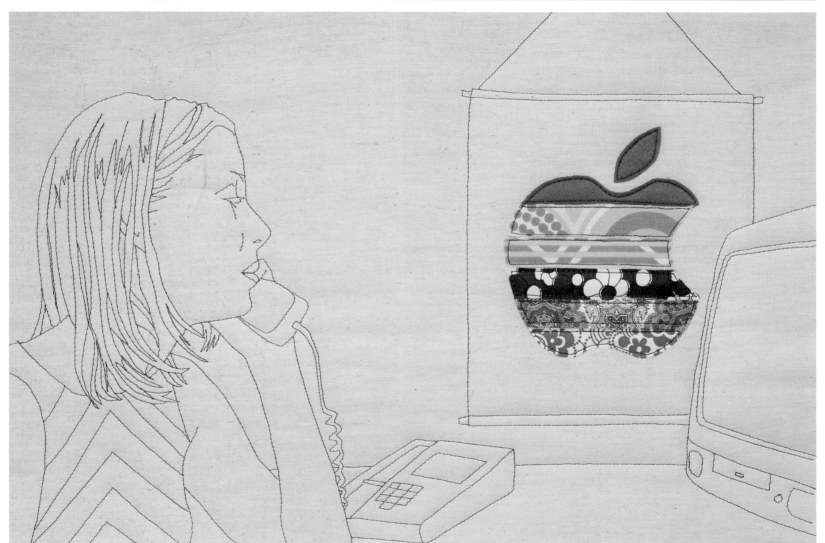

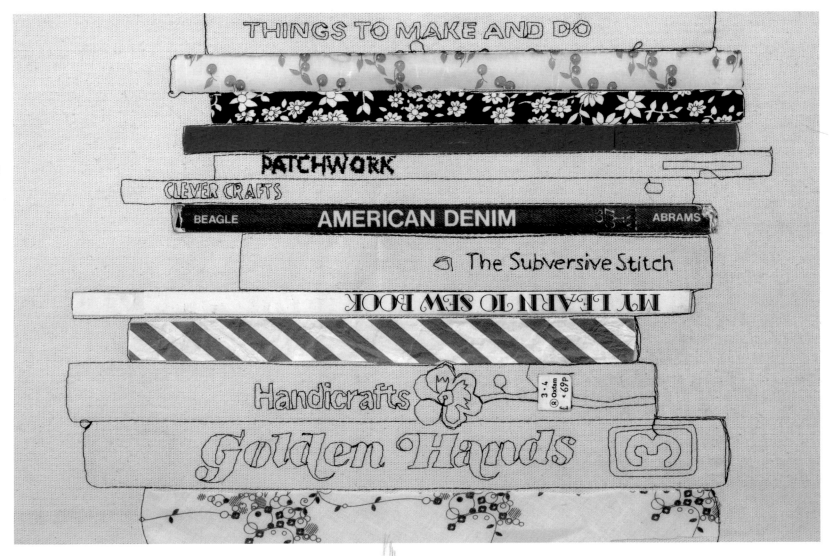

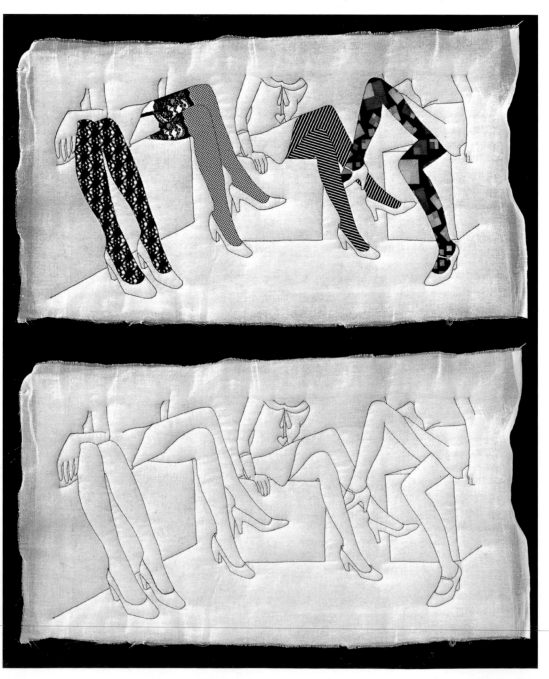

94

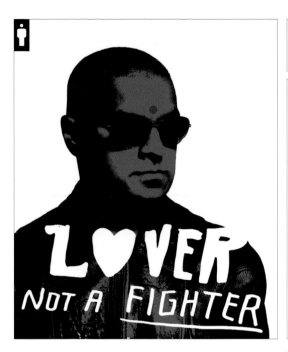

BILLIE JEAN

LONDON-BASED ILLUSTRATOR BILLIE JEAN USES PEN, PENCIL, ACRYLIC PAINT, CORRECTION FLUID AND A CAMERA TO CREATE HIS WORK, THEN REFINES EACH PIECE ON HIS COMPUTER. HIS CLIENTS INCLUDE BLUEPRINT MAGAZINE, BLOOMSBURY PUBLISHING AND SKATEWEAR LABEL HOWIES, FOR WHOM HE CREATED ILLUSTRATIONS FOR THE POINT OF SALE WITH A POINT OF VIEW CAMPAIGN. BILLIE JEAN ALSO WORKS ON WHAT HE DESCRIBES AS "HOME-GROWN" TYPEFACES AND AN ONGOING SERIES OF DRAWINGS OF ANALOGUE DRUM MACHINES. HE IS CURRENTLY CREATING BOTH ILLUSTRATIONS AND PHOTOGRAPHY FOR A NEW STYLE MAGAZINE FOR HI PUBLISHING. HIS SOURCES OF INSPIRATION INCLUDE THE PERIODIC TABLE, SATYAJIT RAY FILMS, THE CARD GAME TOP TRUMPS AND THE TYPEFACE COOPER BLACK.

BELOW/GERMAN EFFICIENCY

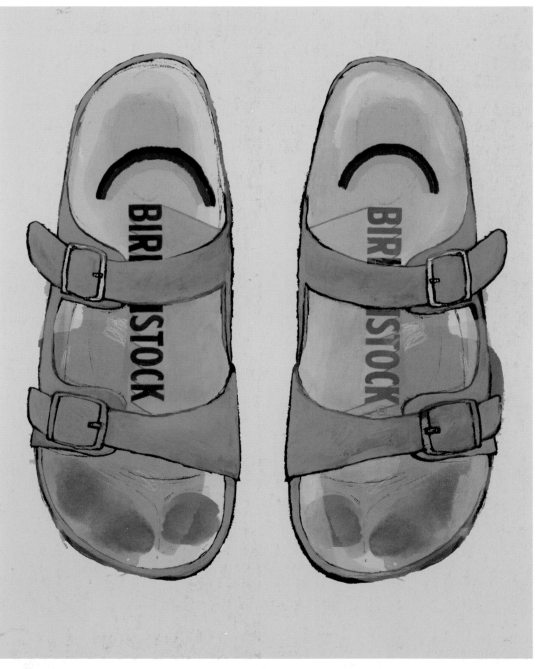

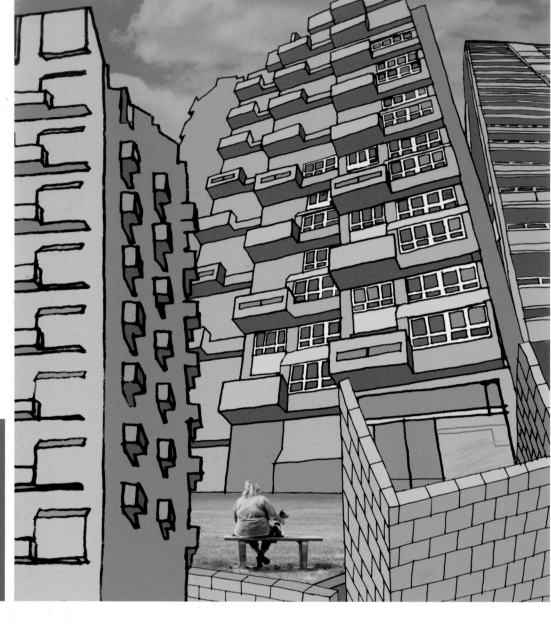

HA REND
ND ERED

BILLIE JEAN

ABOVE/LEFT/HAND RENDERED
ABOVE/RIGHT/HOMES AND GARDEN
OPPOSITE/WHAT THE WORLD NEEDS NOW

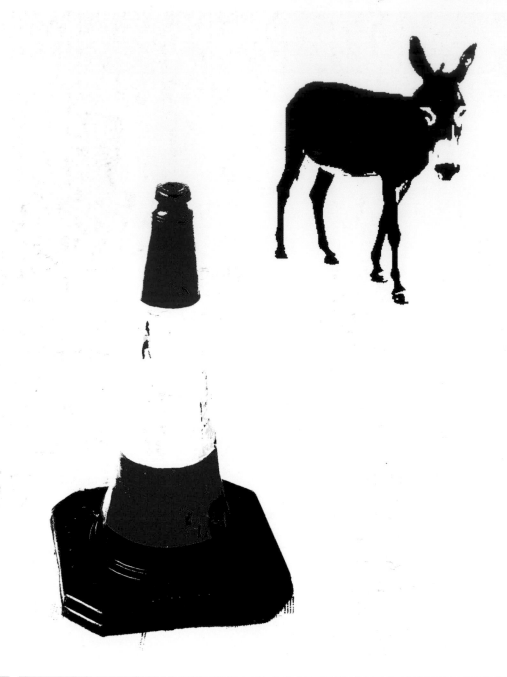

PATRICK THOMAS

BARCELONA-BASED DESIGNER AND ILLUSTRATOR PATRICK THOMAS IS CO-FOUNDER OF
DESIGN STUDIO LAVISTA, SET UP IN 1998 WITH SPANISH DESIGNER ANGELA BROGGI. BORN IN
LIVERPOOL, THOMAS COMPLETED HIS CREATIVE TRAINING AT THE ROYAL COLLEGE OF ART IN
LONDON BEFORE DECIDING TO LEAVE BRITISH SHORES FOR THE WARMER CLIMES OF SPAIN.
INSPIRED BY "DAY-TO-DAY LIFE", THOMAS DIVIDES HIS TIME BETWEEN PRINT AND INTERACTIVE
MEDIA DESIGN AND HAS CREATED BOOKS, IDENTITIES AND CATALOGUES FOR CLIENTS INCLUDING
THE JOAN MIRÓ FOUNDATION, AND JORDI BARNADAS AND CARMEN CLARAMUNT GALLERIES,
ALL IN BARCELONA. NON-COMMERCIAL COMMISSIONS HAVE INCLUDED A CAMPAIGN FOR
THE NATIONAL AIDS AWARENESS PROGRAMME IN SPAIN AS WELL AS THE DESIGN OF A BOOK,
INVITATION AND POSTER CAMPAIGN FOR THE SOCIALIST PARTY OF CATALONIA IN 1999.

ABOVE/BCN_002_ALTA OPPOSITE/TOP/KARATE_002_ALTA
OPPOSITE/BOTTOM/LEFT/FR/GDR_002_ALTA OPPOSITE/BOTTOM/RIGHT/2BIRD_002_ALTA

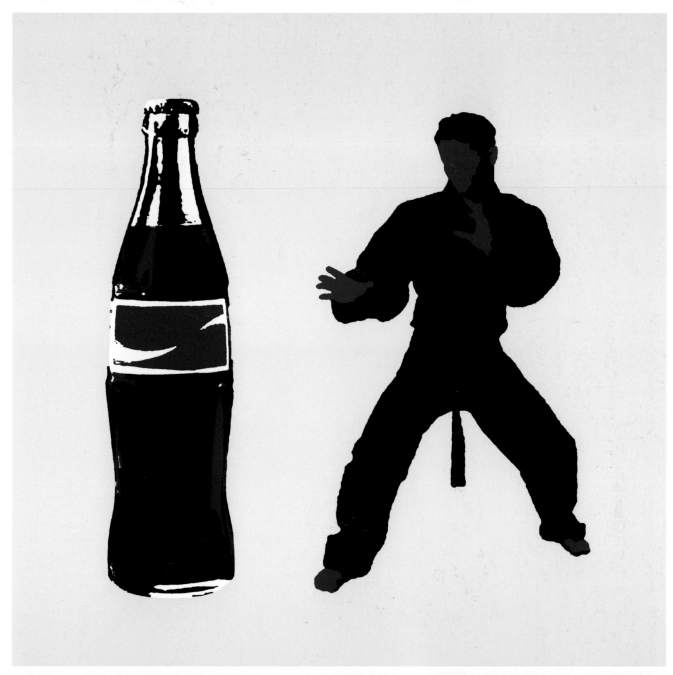
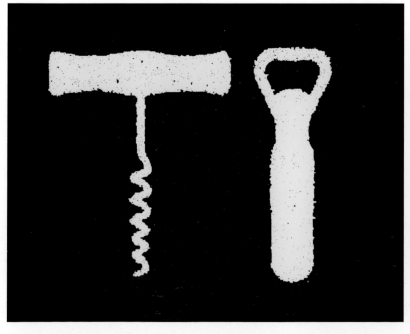
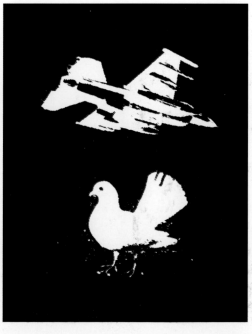

AUDE VAN RYN

AUDE VAN RYN WAS BORN IN BRUSSELS IN 1970 AND MOVED TO THE UK IN 1991. SHE STUDIED GRAPHIC DESIGN AND ILLUSTRATION AT CENTRAL SAINT MARTINS COLLEGE OF ART AND DESIGN, LONDON, THEN GAINED A MASTER OF ARTS DEGREE FROM THE ROYAL COLLEGE OF ART, GRADUATING IN 1997. VAN RYN'S CLIENTS INCLUDE ALMOST EVERY BRITISH BROADSHEET NEWSPAPER, THE NEW YORK TIMES, THE BOSTON GLOBE, THE NEW SCIENTIST, HARPERS US, PENGUIN, NAT WEST AND ORANGE. SHE ALSO DEDICATES TIME TO PRODUCING HAND-MADE BOOKS, WHICH SHE SELLS AT ARTIST'S BOOK FAIRS, AND TRAVEL SKETCHBOOKS. SHE USES PAINT, PENCIL, PRINTMAKING AND A COMPUTER TO CREATE HER ARTWORK.

BELOW/ILLUSTRATION FOR HOLLAND & BARRETT MAGAZINE HEALTHY
OPPOSITE/TOP/ILLUSTRATION FOR THE AVENUE SECTION OF THE CANADIAN NATIONAL POST OPPOSITE/BOTTOM/CARNET DE VOYAGE

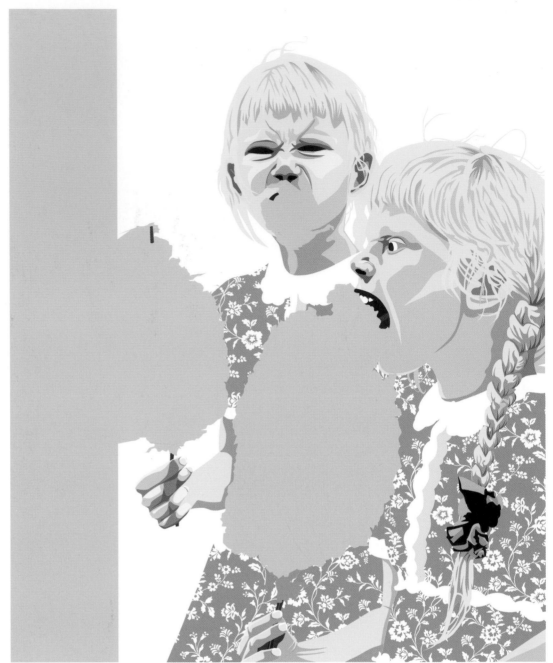

RINZEN

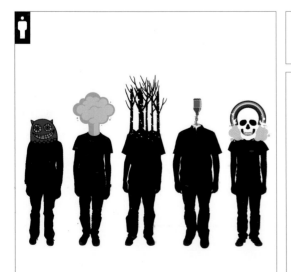

AUSTRALIAN COLLECTIVE RINZEN IS MADE UP OF RILLA ALEXANDER, STEVE ALEXANDER, ADRIAN CLIFFORD, CRAIG REDMAN AND KARL MAIER, ALL GRADUATES IN GRAPHIC DESIGN FROM QUEENSLAND COLLEGE OF ART. THEY WORK ON A RANGE OF CLIENT AND PERSONAL PROJECTS ACROSS PRINT, WEB DESIGN, ILLUSTRATION, FONT AND CHARACTER CREATION, MOTION GRAPHICS, ANIMATION AND MUSIC. RINZEN FORMED IN 2000 AFTER COLLABORATING ON RMX: A VISUAL REMIX PROJECT (WWW.RMXXX.COM) FOR WHICH THEY "REMIXED" EACH OTHER'S WORK IN A CHINESE WHISPERS-LIKE SEQUENCE. "AT THE TIME OF MEETING WE WERE ALL DEEP IN CORPORATE DESIGN PROJECTS FOR VARIOUS CLIENTS AND EMPLOYERS," EXPLAINS RILLA ALEXANDER. "WE FELT THE NEED TO DO A COLLABORATIVE PROJECT OUTSIDE THESE RESTRICTIONS AND THE BLUEPRINTS FOR RINZEN WERE SCRAWLED IN A WINE-SOAKED NAPKIN DURING THE CHAOTIC RMX PROJECT MEETINGS." CLIENTS TO DATE INCLUDE CLOTHING LABELS MOOKS AND DIESEL, THE FACE, WIRED, ADVERTISING AGENCY TBWA AND WARNER BROS.

ABOVE/FLOSS DAILY OPPOSITE/WAIKIKI - HERE COMES SEPTEMBER

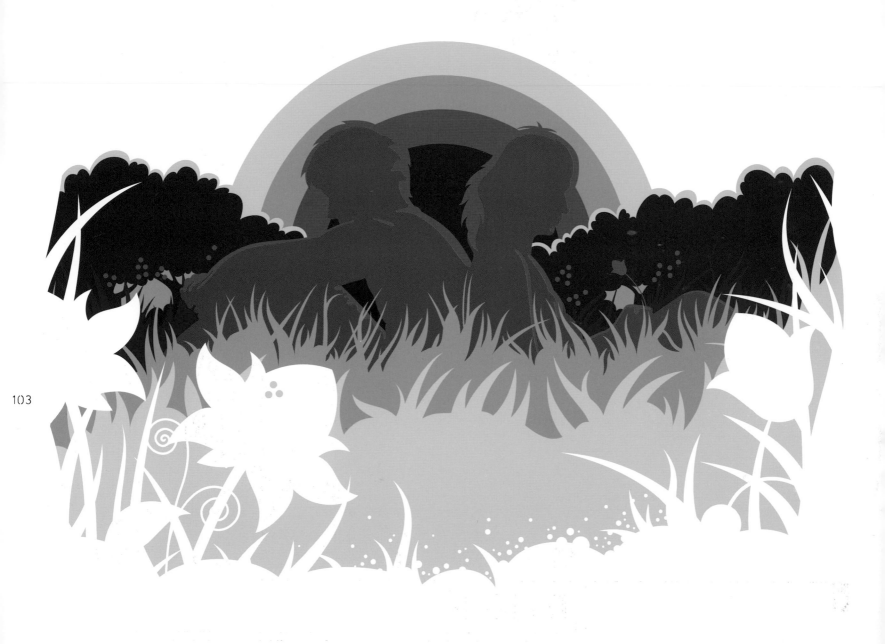

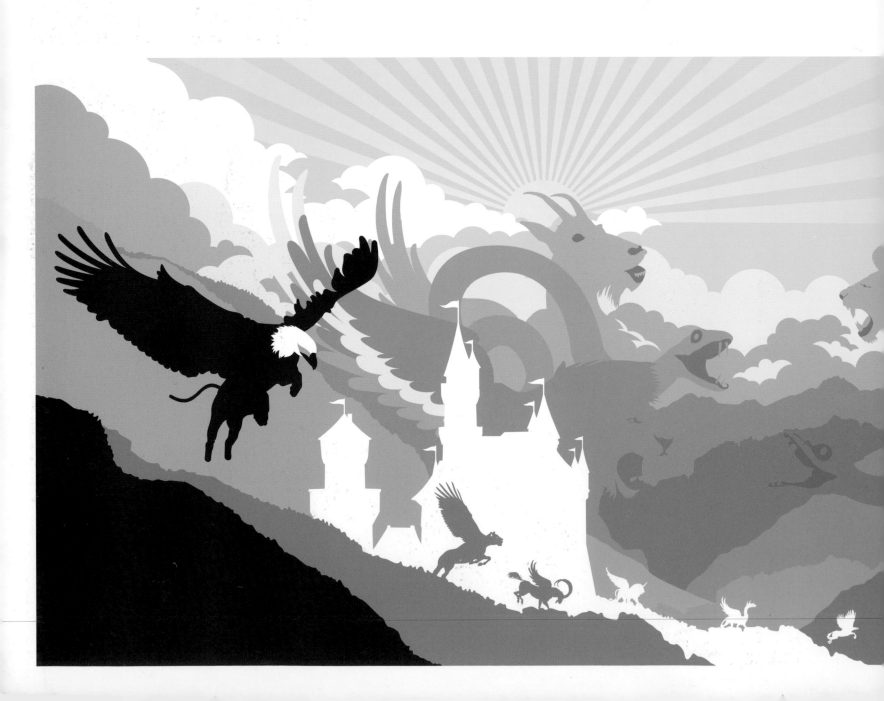

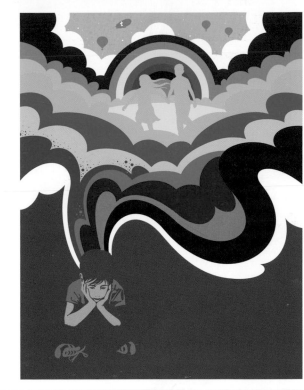

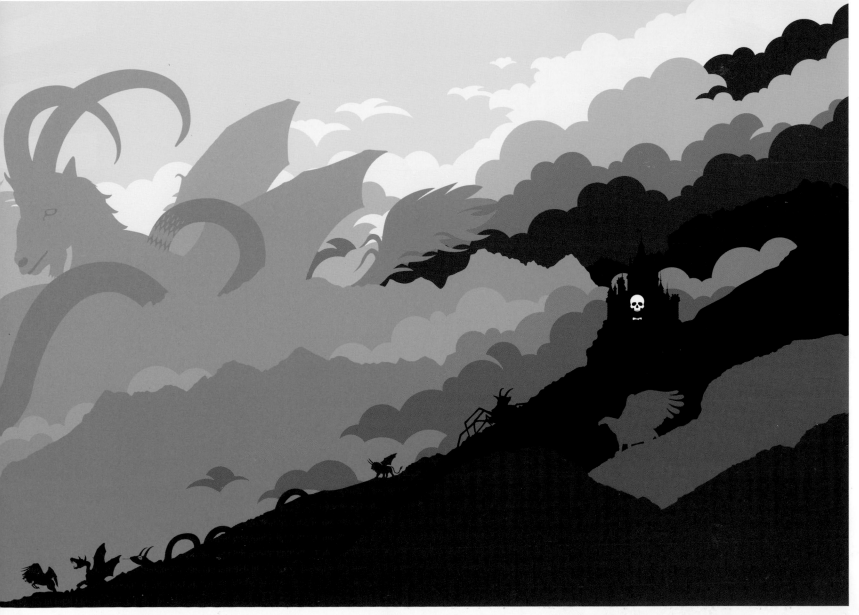

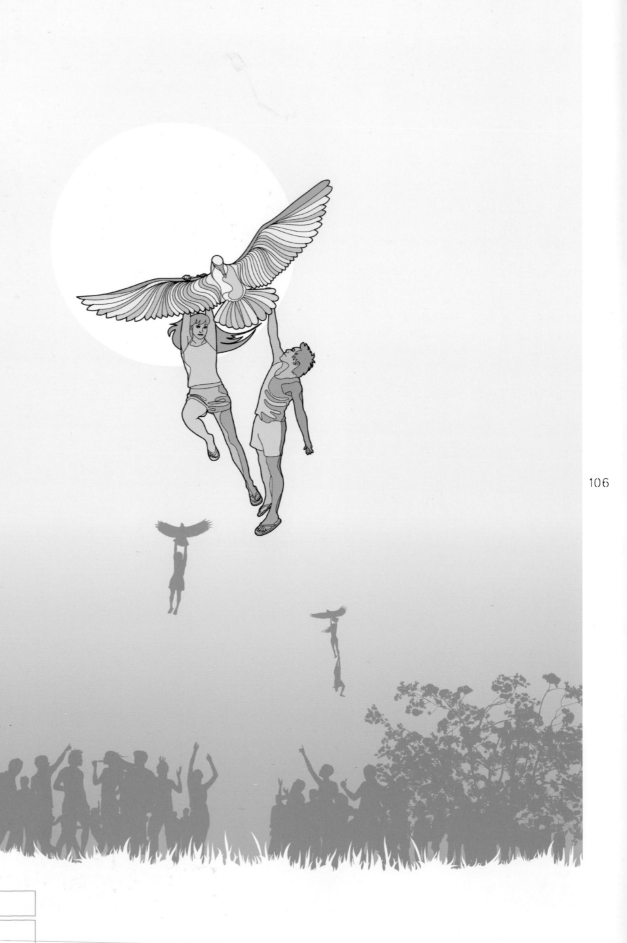

RINZEN

ABOVE & OPPOSITE/MOONLIGHT

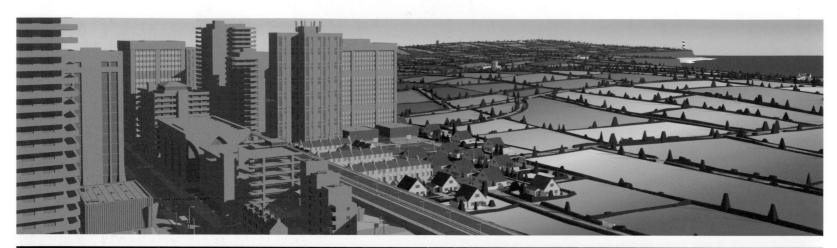

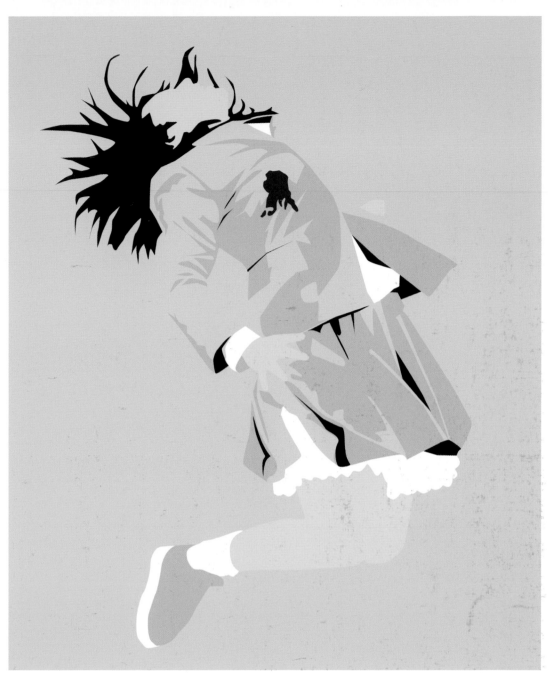

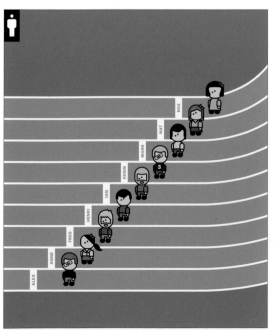

AIRSIDE

FRED DEAKIN, NAT HUNTER AND ALEX MACLEAN LAUNCHED AIRSIDE IN 1999. BASED IN LONDON AND HAVING GROWN TO NINE PEOPLE, THE AGENCY PRODUCES ILLUSTRATION, WEBSITES, PRINT, IDENTITIES AND, INCREASINGLY, MOTION GRAPHICS FOR A RANGE OF ARTS AND MEDIA CLIENTS, INCLUDING THE WHITE CUBE AND SERPENTINE GALLERIES IN LONDON, PHOTOGRAPHER NADAV KANDER, DJ PAUL OAKENFOLD, CHANEL, CARHARTT AND FRED DEAKIN'S ELECTRONICA GROUP LEMON JELLY. AIRSIDE ALSO PRODUCES MERCHANDISE WHICH IS SOLD ONLINE AND IS FAST BECOMING COLLECTABLE: THEIR MOST POPULAR T-SHIRT TO DATE FEATURES AN IMAGE CREATED TO PROMOTE THE JAPANESE FILM BATTLE ROYALE, RELEASED IN 2001. THE GROUP HOPES THAT THE SHOP, WHICH SELLS T-SHIRTS, SCREENPRINTS, KNITTED TOYS AND MODELS, WILL ONE DAY BECOME AS IMPORTANT A PART OF THEIR BUSINESS AS CLIENT WORK.

OPPOSITE/LEMON JELLY - LOST HORIZONS CD AND LP COVER
ABOVE/PROMOTIONAL IMAGE FOR THE MOVIE BATTLE ROYALE

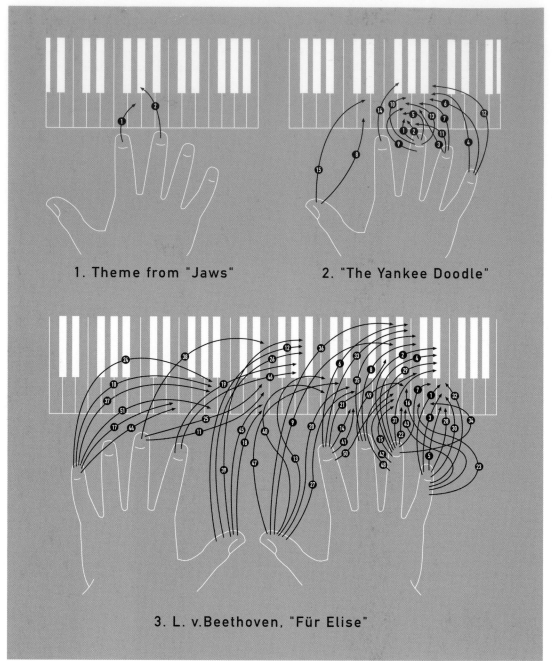

1. Theme from "Jaws" 2. "The Yankee Doodle"

3. L. v. Beethoven, "Für Elise"

CHRISTOPH NIEMANN

GERMAN-BORN DESIGNER AND ILLUSTRATOR CHRISTOPH NIEMANN'S COMMERCIAL CLIENTS HAVE INCLUDED THE NEW YORK TIMES, ROLLING STONE MAGAZINE AND THE NEW YORKER. NOW BASED IN NEW YORK, HE ALSO PUBLISHES A SERIES OF ILLUSTRATED BOOKS, ENTITLED 100%, WITH MANHATTAN-BASED GRAPHIC ARTIST NICHOLAS BLECHMAN. ASKED WHAT THE FUTURE MIGHT HOLD FOR ILLUSTRATION AS A DISCIPLINE, NIEMANN REPLIES: "I CERTAINLY THINK THAT THERE WILL BE MORE OF A SHIFT TO A NEW KIND OF SELF-AUTHORED ILLUSTRATION THAT DOES NOT ONLY FUNCTION AS AN AMENDMENT TO AN ARTICLE BUT RATHER AS A FREE-STANDING PIECE OF EDITORIAL CONTENT IN ITS OWN RIGHT." EMPLOYING TOOLS INCLUDING "ALMOST ANYTHING REALLY", NIEMANN DECLARES: "I TRY TO COME UP WITH AN IDEA FIRST, AND THEN FIND THE APPROPRIATE GRAPHIC STYLE TO SUPPORT IT."

ABOVE/HOW TO PLEASE ELISE OPPOSITE/MY ABSTRACT NEW YORK

FIFTEEN SECONDS TOO LATE

CREAM-BLACK-LIGHT
2%-DECAF-SKIM
HALF-AND-HALF-3 SUGARS-REGULAR

CREAM CHEESE BEFORE THE JOB INTERVIEW

THE TRANS-ATLANTIC OUTLET DILEMMA

ETERNAL GUM

A-B-C-D-E-F-G-J-L-M-N-Q-R-S-Z-
1-2-3-4-5-6-7-9

111

AIRPLANE BEHIND THE TWIN TOWERS

ROACH TRAPS IN THE KITCHEN CABINET

FULL MOON SEEN THROUGH A POPPY SEED BAGEL

JAMES GRAHAM

JAMES GRAHAM STUDIED ILLUSTRATION AT THE UNIVERSITY OF THE WEST OF ENGLAND, BRISTOL, GRADUATING IN 2000. HE HAS EXHIBITED HIS WORK AT MAJOR BOOKFAIRS IN BOLOGNA, ITALY, AND MONTREUIL, PARIS, AND HAS WORKED FOR DESIGN GROUPS AND NEWSPAPERS, INCLUDING THE INDEPENDENT. HIS INSPIRATION IS DRAWN FROM THE GRAPHIC DESIGN OF EASTERN EUROPE, OLD PHOTOGRAPHS, CULTURAL TRADITIONS FROM AROUND THE WORLD, DISCARDED GRAPHICS, UNWANTED SCRAPS OF PRINTED PAPER, TRADITIONAL WOODBLOCK TYPOGRAPHY AND SHORT STORIES. HIS IDEAS ARE CONVEYED THROUGH A PLAYFUL GRAPHIC STYLE, USING A MIX OF TRADITIONAL MEDIUMS SUCH AS CRAYONS, PENCIL AND PRINT.

BELOW/HOLLYWOOD
OPPOSITE/TOP/JAMJOT OPPOSITE/BELOW/THE PARK

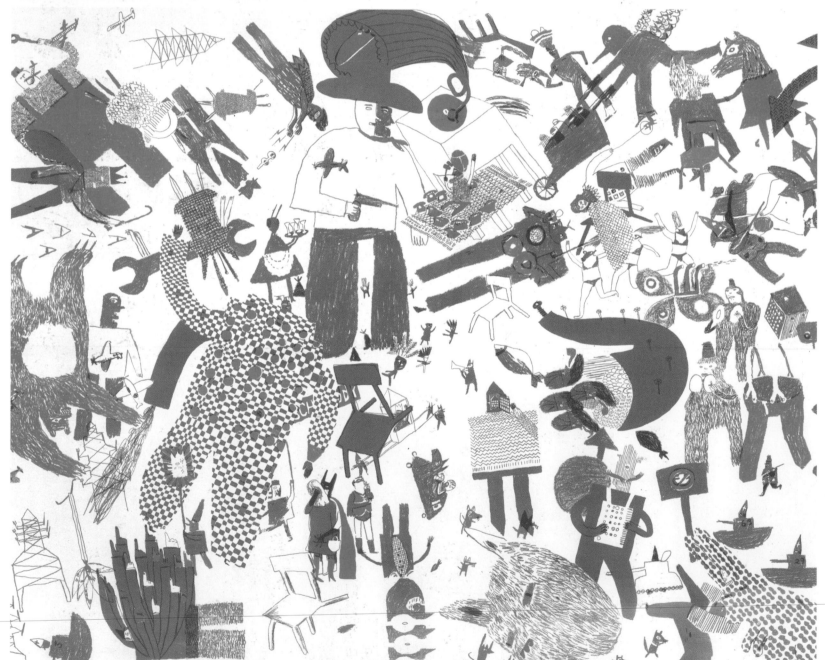

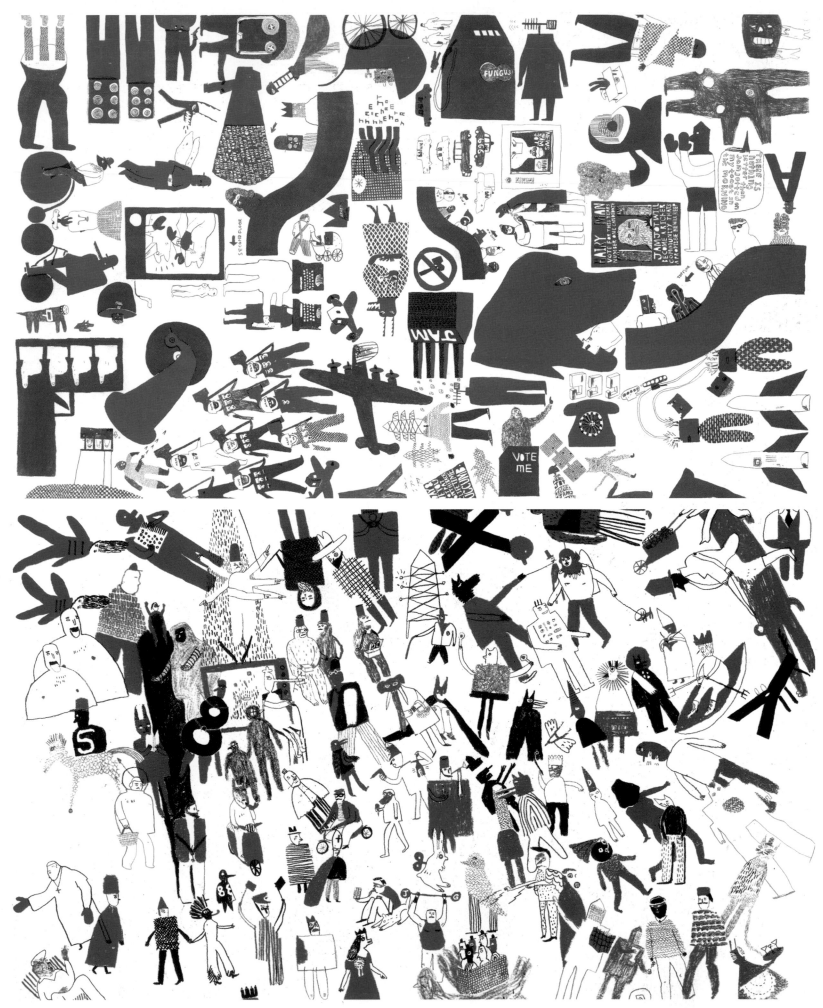

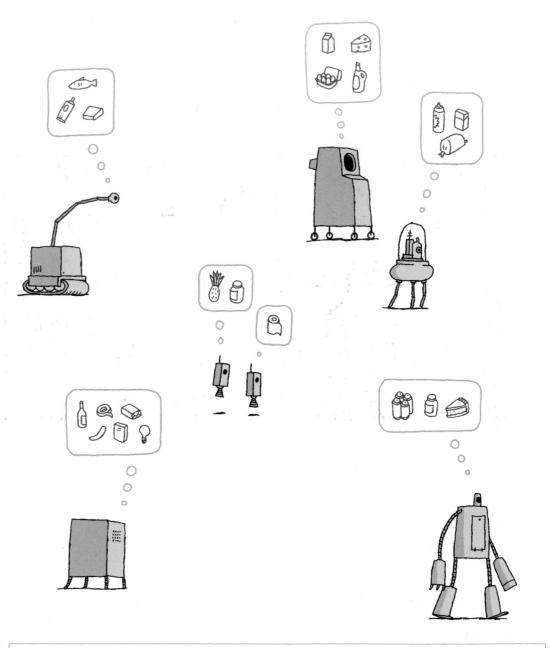

TOM GAULD

SCOTTISH ILLUSTRATOR AND COMIC BOOK ARTIST TOM GAULD HAS BEEN BASED IN LONDON SINCE HE GRADUATED WITH A MASTER OF ARTS DEGREE FROM THE ROYAL COLLEGE OF ART IN 2001. USING PENCIL, MICRO PEN AND A MAC, GAULD CREATES WITTY, BEAUTIFULLY DRAWN ILLUSTRATIONS FOR CLIENTS INCLUDING PENGUIN, ORANGE AND TIME OUT, FOR WHOM HE PRODUCES A COMIC STRIP ENTITLED "MOVE TO THE CITY". MUCH OF GAULD'S TIME IS DEDICATED TO CREATING COMIC BOOKS: TO DATE HE HAS PUBLISHED FOUR UNDER THE NAME OF CABANON PRESS. ASPIRATIONS FOR THE FUTURE INCLUDE "MAKING COMICS UNTIL I GET VERY GOOD AT IT". HE WOULD LIKE "TO SEE NEWSPAPERS AND MAGAZINES DEVOTE A DECENT SIZE SPACE TO ILLUSTRATIONS AND COMIC STRIPS, MAYBE A FULL BROADSHEET PAGE, AS THEY DID AT THE BEGINNING OF THE LAST CENTURY."

ABOVE/SEVEN ROBOTS GOING TO THE SHOPS OPPOSITE/HILLTOP

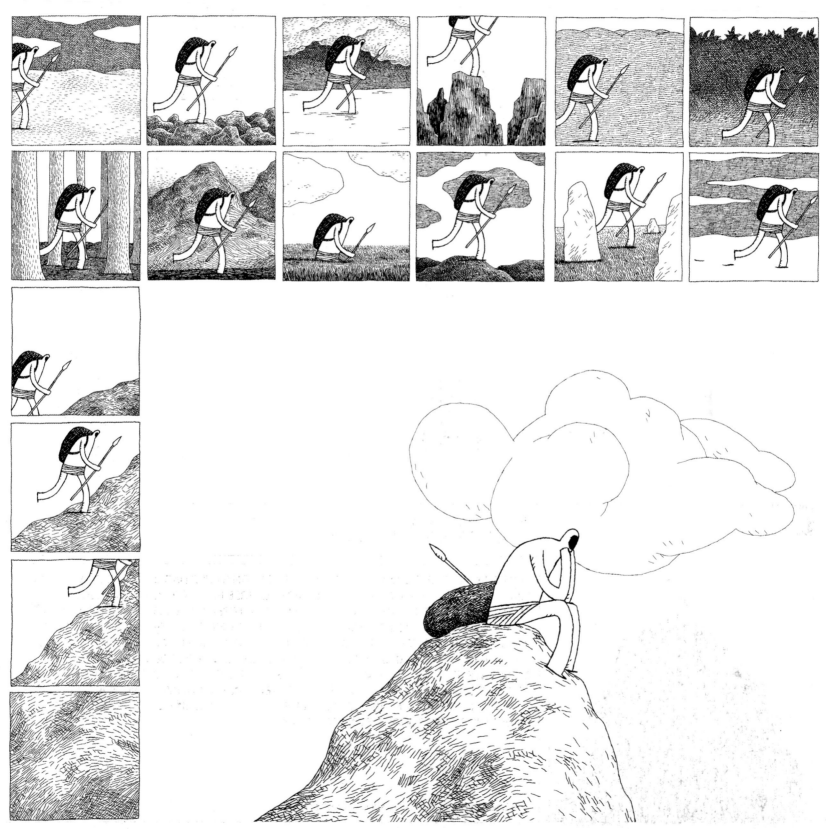

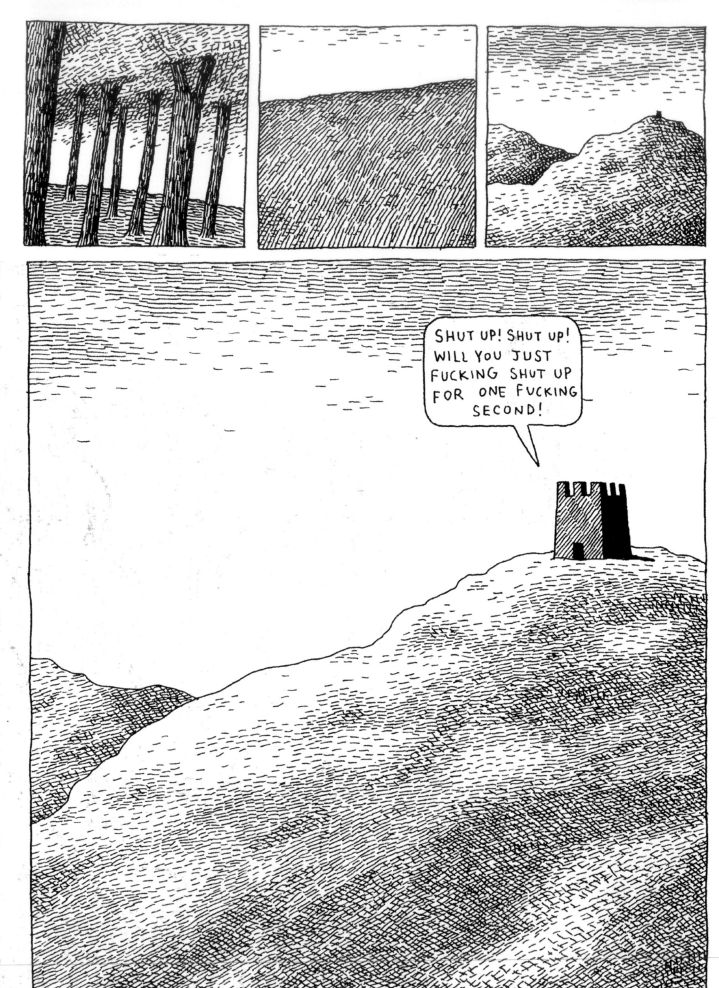

117

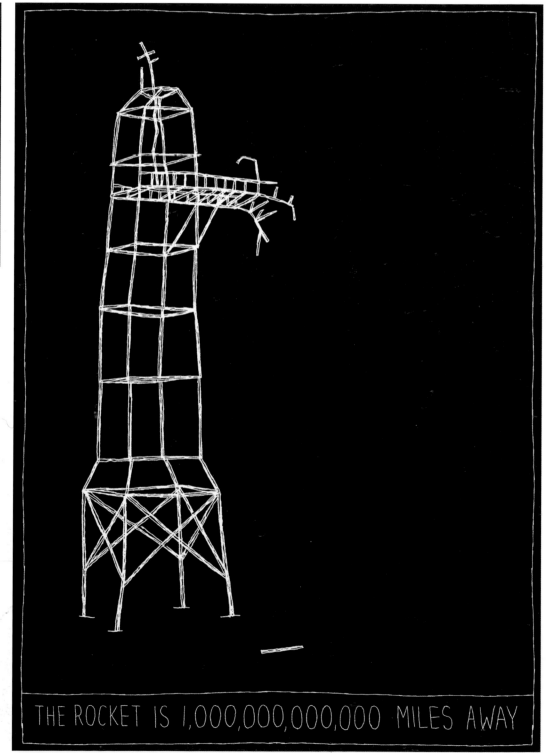

CRÉME CARAMEL

THE ROCKET IS 1,000,000,000,000 MILES AWAY

SIMONE LIA

ARTIST AND ILLUSTRATOR SIMONE LIA GRADUATED WITH A BACHELOR OF ARTS DEGREE IN ILLUSTRATION FROM THE UNIVERSITY OF BRIGHTON IN 1995, THEN GAINED A MASTER OF ARTS IN COMMUNICATION ART AND DESIGN FROM THE ROYAL COLLEGE OF ART IN LONDON. SHE OCCASIONALLY WORKS IN ADVERTISING, PRINT AND EDITORIAL, BUT DEDICATES MUCH OF HER TIME TO HER OWN PUBLICATIONS. TO DATE SHE HAS CREATED FOUR COMIC BOOKS UNDER THE NAME OF CABANON PRESS, WHICH SHE FOUNDED WITH TOM GAULD. SHE HAS WRITTEN AND ILLUSTRATED FOUR BOOKS FOR GULLANE, DAVID AND CHARLES, EGMONT AND METHUEN PUBLISHING HOUSES, AND HAS ALSO ILLUSTRATED SEVERAL CHILDREN'S BOOKS FOR MAMMOTH. LIA'S TOOLS INCLUDE PENCIL, DIP-PEN, PAINT AND A COMPUTER AND SHE HAS RECENTLY BEEN EXPERIMENTING WITH SCREENPRINTING.

BELOW/ILLUSTRATION FROM MONKEY AND SPOON OPPOSITE/BUNNIES THAT HAVE SEEN TRAGEDY

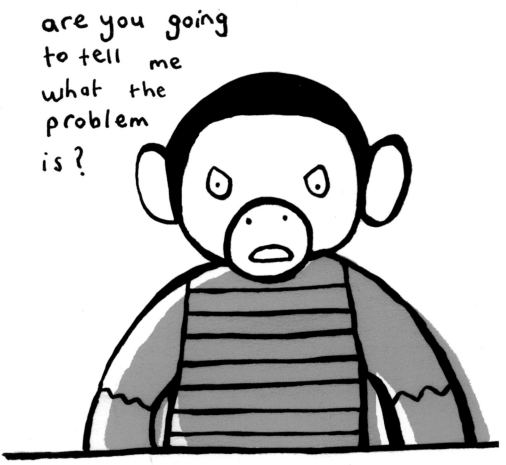

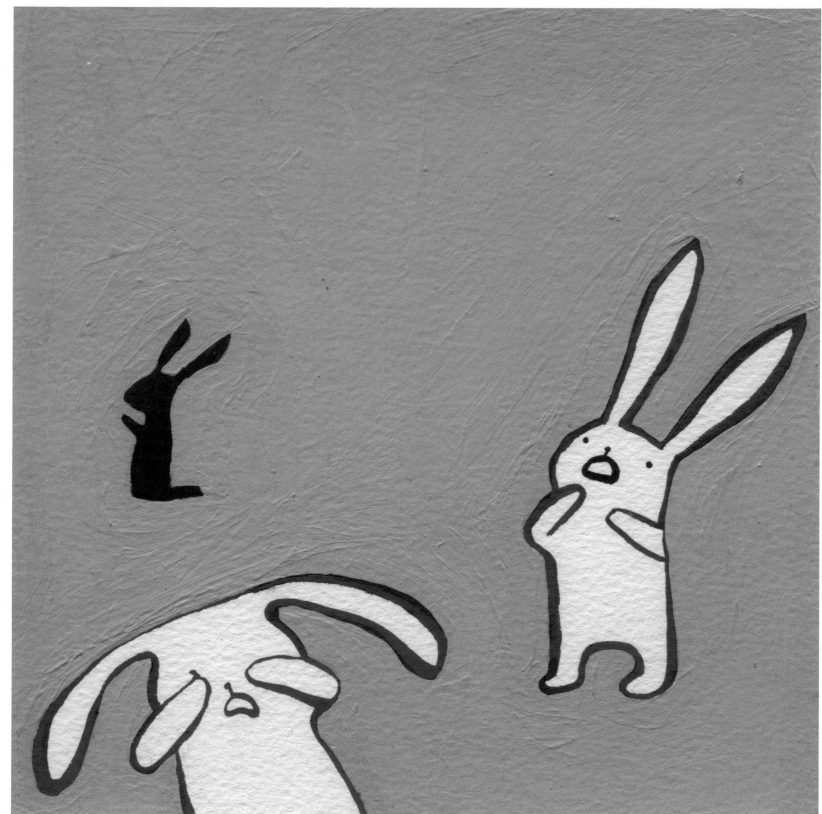

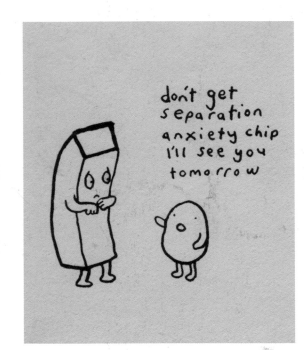

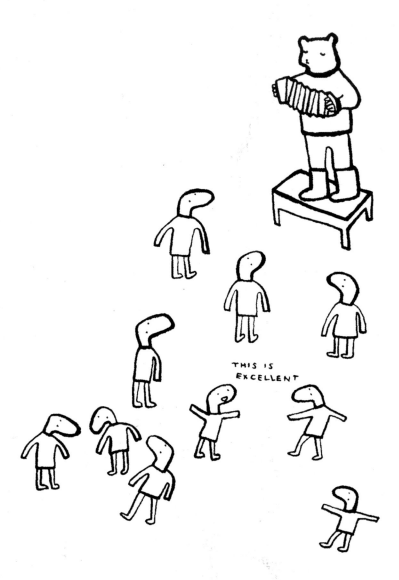

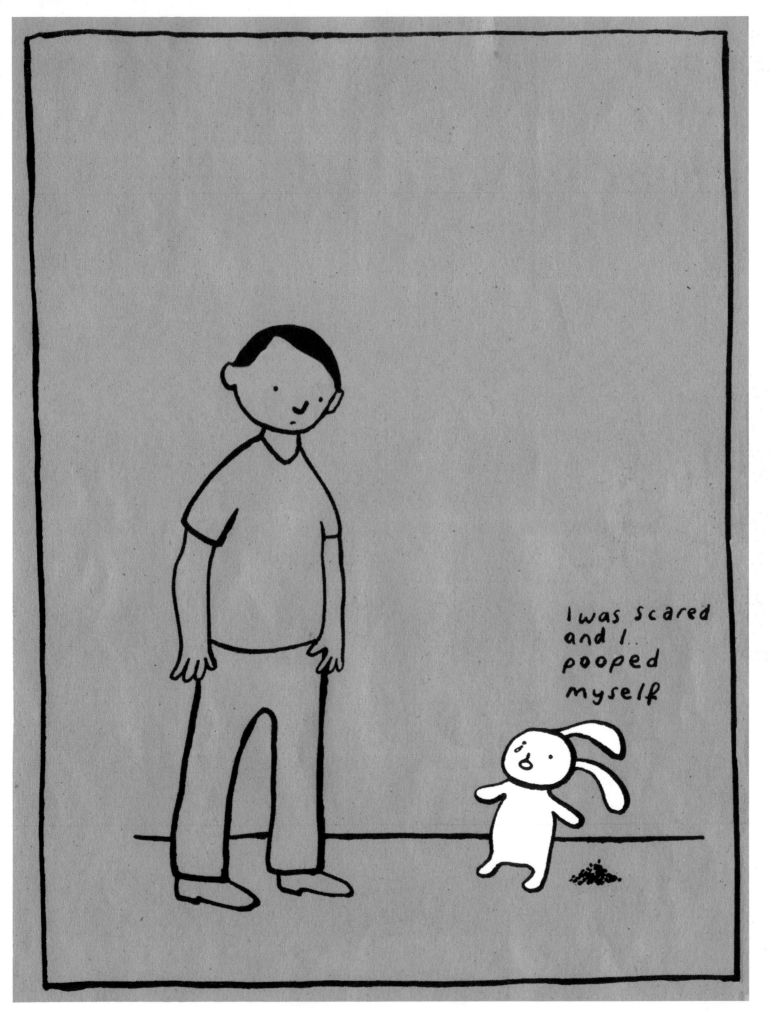

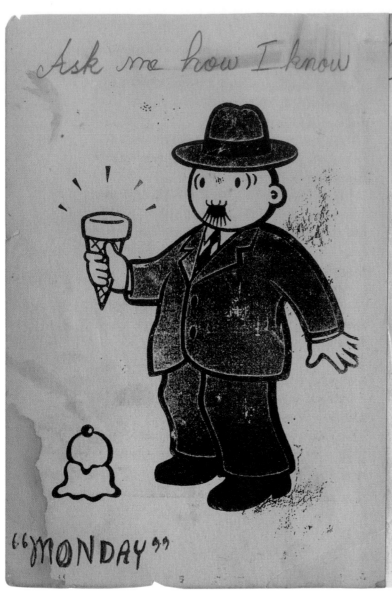

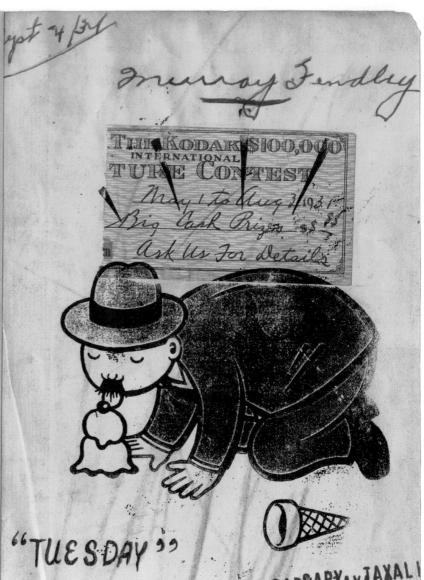

GARY TAXALI

INDIAN-BORN GARY TAXALI, NOW BASED IN TORONTO, CLAIMS HE HAS ALWAYS BEEN AN ILLUSTRATOR AT HEART: EVEN AT THE AGE OF FOUR, HIS FAVOURITE ACTIVITY AT SCHOOL WAS TO DRAW THE CHARACTERS AND SCENES DESCRIBED IN STORIES TOLD BY HIS TEACHER, AS THEY WERE READ ALOUD. TAXALI'S TOOLS INCLUDE ALKYDS (QUICK-DRYING OILS) WHICH HE PAINTS ON TO MASONITE, INK, COLLAGE AND LIQUID PAPER. HE COMBINES THESE WITH THE USE OF ANTIQUE PAPER TO CREATE HIS CHARMING AND ORIGINAL ILLUSTRATIONS WHICH ARE INSPIRED BY ASIAN PACKAGING, MEXICAN GRAFFITI, POSTER ART AND OLD FONTS. HIS CLIENTS HAVE INCLUDED TIME WARNER, NEWSWEEK, COCA-COLA AND MTV. TAXALI ALSO EXHIBITS AS A FINE ARTIST THROUGHOUT THE UNITED STATES AND TEACHES ILLUSTRATION AT BOTH ONTARIO COLLEGE OF ART AND DESIGN AND SHERIDAN COLLEGE. HIS PLANS FOR THE FUTURE INCLUDE A SERIES OF CHILDREN'S BOOKS AND HIS OWN ANIMATED CARTOON SHOW.

ABOVE/MONDAY/TUESDAY OPPOSITE/BINCO

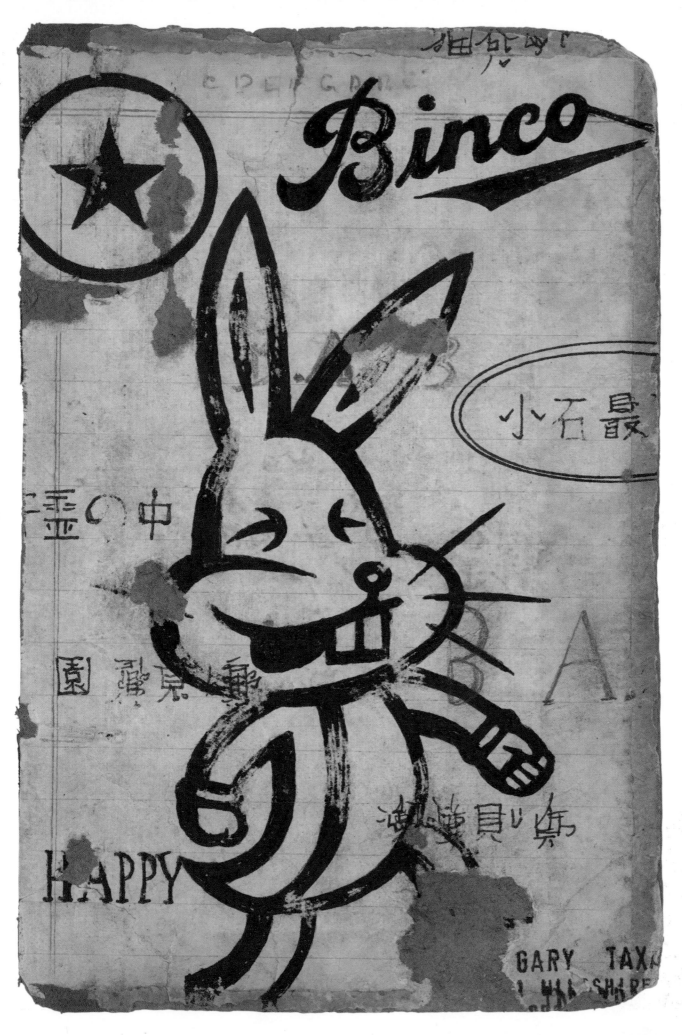

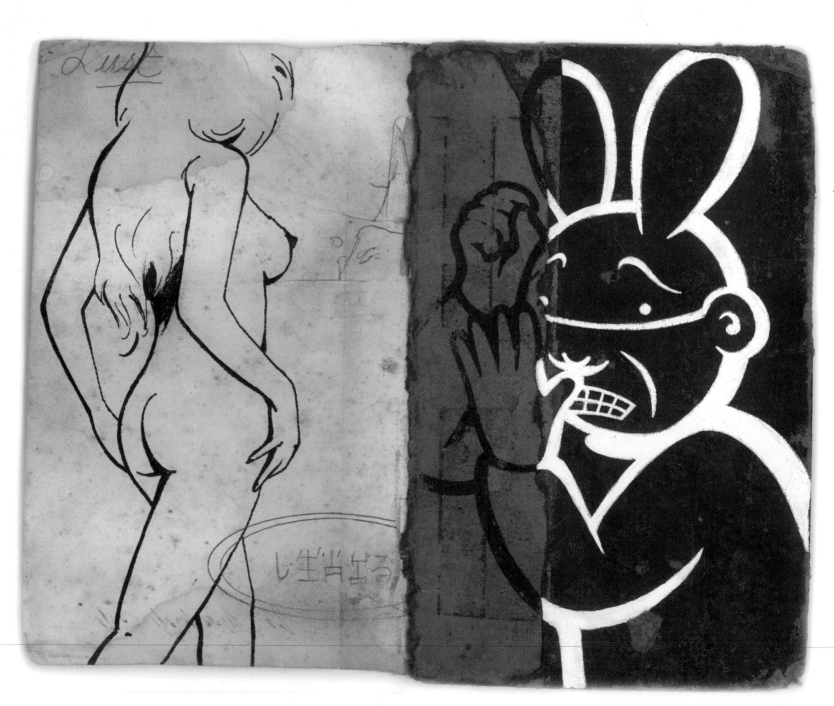

PETER ARKLE

NEW YORK-BASED ILLUSTRATOR PETER ARKLE DESCRIBES HIS STYLE AS "SOMETIMES REALISTIC IN A SIMPLE WAY AND SOMETIMES IN A RIDICULOUSLY OBSESSIVE, EVEN A LITTLE MANIC, WAY". WITH THE USE OF A FOUNTAIN PEN, PENCIL, CORRECTION FLUID, MARKER PENS, GLUE, CHEAP PHOTOCOPYING PAPER, ACETATE SHEETS, A LIGHT BOX, ACRYLIC AND WATER-COLOUR PAINTS AND, SINCE LAST YEAR, A COMPUTER, ARKLE HAS CREATED WORK FOR THE NEW YORK TIMES, TIME OUT NEW YORK, NIKE, HERSHEY'S, THE BIG ISSUE AND THE WALL STREET JOURNAL. HIS SELF-PUBLISHED NEWSLETTER PETER ARKLE NEWS CONTAINS HIS MORE PER-SONAL WORK. "ITS MAIN CONTENT IS STORIES OF EVERYDAY LIFE; WRITTEN, ILLUSTRATED, HANDWRITTEN, PHOTOCOPIED, RUBBER-STAMPED, LINO PRINTED, STAPLED AND MAILED BY ME TO ABOUT SIXTY SUBSCRIBERS."

BELOW/MAGAZINE AD FOR HERSHEY'S CHOCOLATE

125

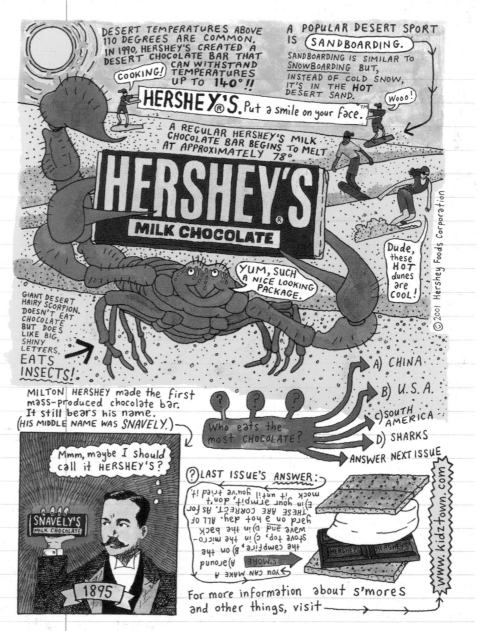

Design creative director. Worldstudio founder. D.C.'s coolest DJs. partner and AIGA president emeritus. gaming and collective music making. journalist and "Voice" moderator extraordinaire

ctive.

teed

To

de

f

THE HISTORIC MARRIOTT WARDMAN PARK HOTEL is located atop a hill near the National Zoological Gardens in the North West district of the city. The 1918 building, listed on the National Register of Historic Places, is set within a lusciously landscaped 16-acre → landmark estate. in the fitness cent trail through adjac. or explore the hote that will be starting March. Plus the hot

N GOLDBERG, k cover designer.

BOB ZENI, executive director of the Voting Experience Redesign Initiative.

CLEMENT MOK, AIGA president.

LUKE HAYMAN, Brill's Content creative director.

MATT GROENING, "The Simpson's" creator.

MARCIA LAUSEN, design educator, University of Illinois at Chicago.

BEN RUBIN, Sound and multimedia designer.

→ $68 to $105. Call **1 800 USA RAIL** or visit www.amtrak.com

To reserve **SPECIAL** car rentals, call your tr or Budget directly at **80** and remember to quote th reference number UO618

BUDGET RENT A CAR is the official car rental company of the "Voice" conference.

The list may change. Please visit: **www.voice.aiga.org** for updates and more information.

MAJOR SPONSORS:

A, oster

Fox River Paper Co.

Dickson's

Adobe Systems, Inc.

Aquent

Domtar Paper

Fonts.

EFERENCE

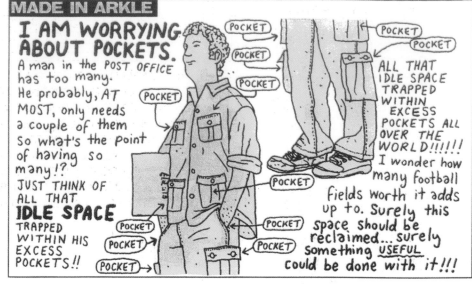

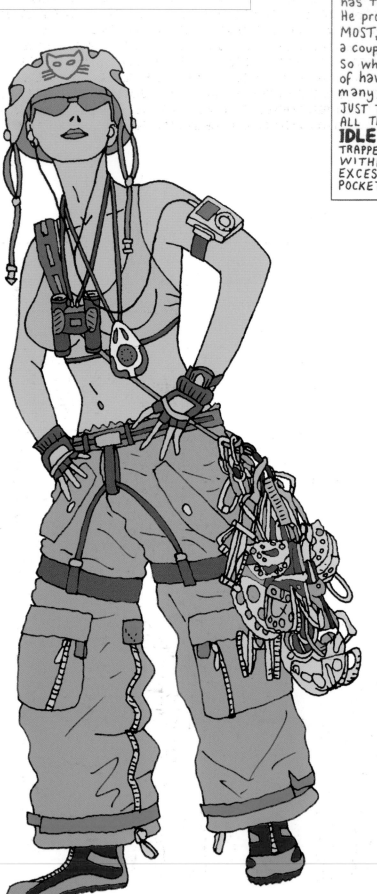

128

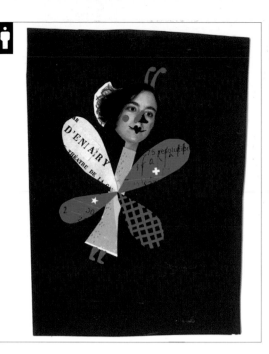

SARA FANELLI

SARA FANELLI WAS BORN IN FLORENCE BUT MOVED TO LONDON TO STUDY, COMPLETING A BACHELOR OF ARTS DEGREE IN GRAPHIC DESIGN AT CAMBERWELL COLLEGE OF ARTS, FOLLOWED BY A MASTER OF ARTS IN ILLUSTRATION AT THE ROYAL COLLEGE OF ART. FANELLI'S WORK CONSISTS MAINLY OF COLLAGE, THOUGH SHE ALSO USES GOUACHE. CLIENTS INCLUDE THE ROYAL MAIL, THE NEW YORKER AND TATE MODERN. FANELLI ALSO DEDICATES MUCH OF HER TIME TO WRITING AND ILLUSTRATING CHILDREN'S BOOKS, MOST RECENTLY DEAR DIARY (2000) AND MYTHOLOGICAL MONSTERS (2002), PUBLISHED BY WALKER BOOKS, AND FIRST FLIGHT (2002) FOR JONATHAN CAPE. SHE IS INSPIRED BY FINE ART, IN PARTICULAR WORK FROM THE DADA AND SURREALIST MOVEMENTS, AND TYPOGRAPHY, GRAPHIC DESIGN AND FILM OF THE SAME PERIOD.

ANNUAL REPORT FOR THE SWEDISH CHEMISTRY BOARD
BELOW/TESTING POLLUTION IN RIVERS

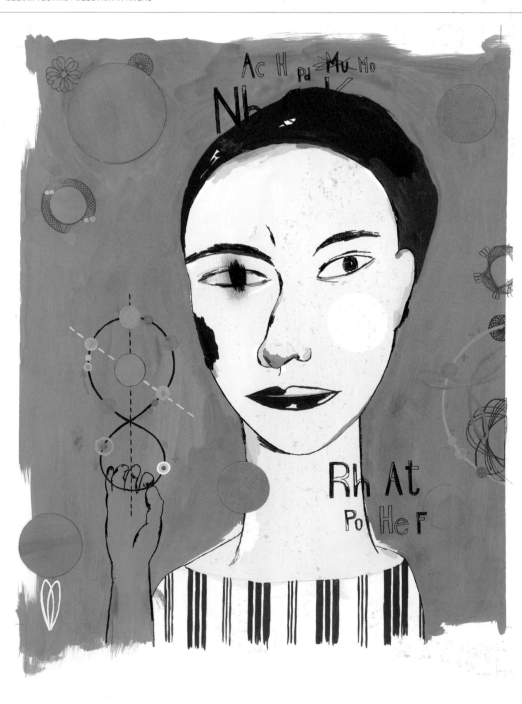

RIGHT/EFFECT OF MAGNESIUM IN HAIR BELOW/COVER
OPPOSITE/LEFT/TEACHING CHEMISTRY IN DIFFERENT LANGUAGES
OPPOSITE/RIGHT/INSPIRATIONAL CHEMISTRY TEACHERS

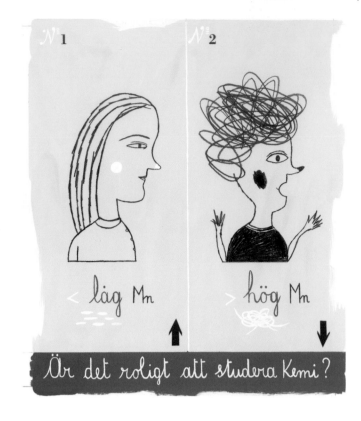

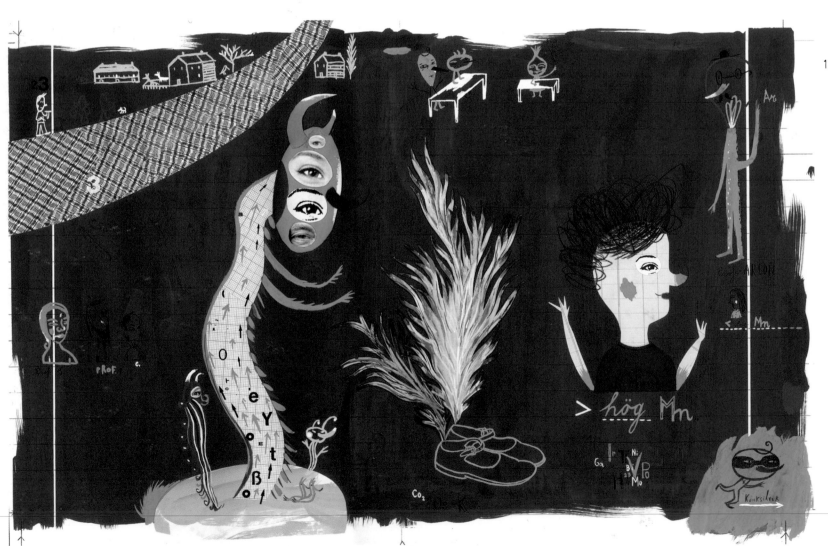

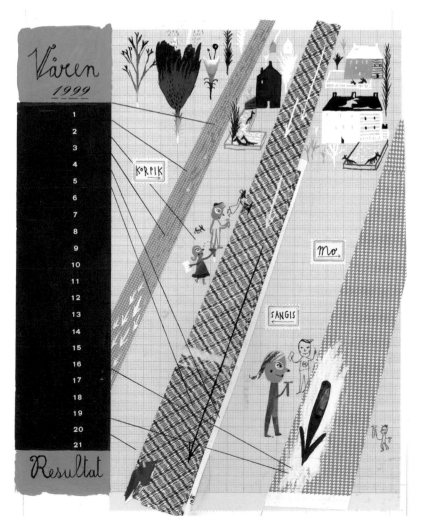

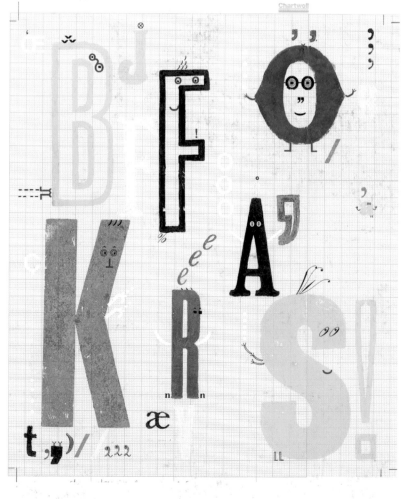

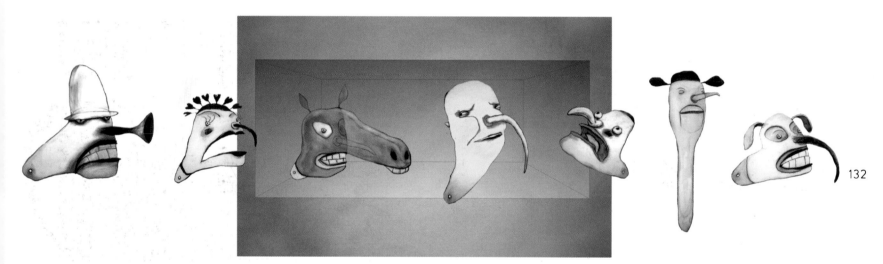

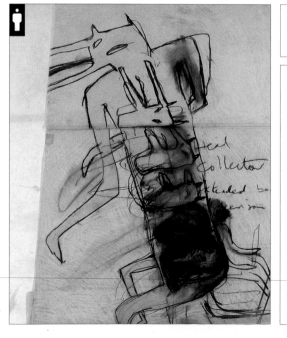

CHIU KWONG MAN

FRENCH–CHINESE IMAGE-MAKER CHIU KWONG MAN IS FASCINATED BY INTERACTIVE WEB-BASED NARRATION. HE DEDICATES MUCH OF HIS TIME TO WORKING ON HIS OWN EXPERIMENTAL INTERACTIVE ANIMATION PROJECTS, CREATING HUNDREDS OF ILLUSTRATIONS AS A STARTING POINT FOR THESE. HIS DRAWINGS ARE CREATED WITH, AMONGST OTHER TOOLS, CHARCOAL AND LARGE PIECES OF PATTERNED PAPER AND CAN BE SEEN ON HIS WEBSITE (WWW.SEXLIESANDFAIRYTALES.NET) ALONGSIDE THE FINAL INTERACTIVE PIECES WHICH USE PHOTOSHOP AND FLASH SOFTWARE. KWONG MAN GREW UP IN LONDON AND COMPLETED A DEGREE COURSE IN ILLUSTRATION AT NORWICH SCHOOL OF ART AND DESIGN. HE THEN LIVED IN HONG KONG AND CHINA FOR EIGHT YEARS BEFORE RETURNING TO THE UK. TODAY HE TEACHES ON BOTH THE BACHELOR OF ARTS AND MASTER OF ARTS COURSES IN VISUAL COMMUNICATION AND ILLUSTRATION AT BIRMINGHAM INSTITUTE OF ART AND DESIGN.

ABOVE & OPPOSITE/CHARACTER STUDIES FOR PUNCH & JUDY

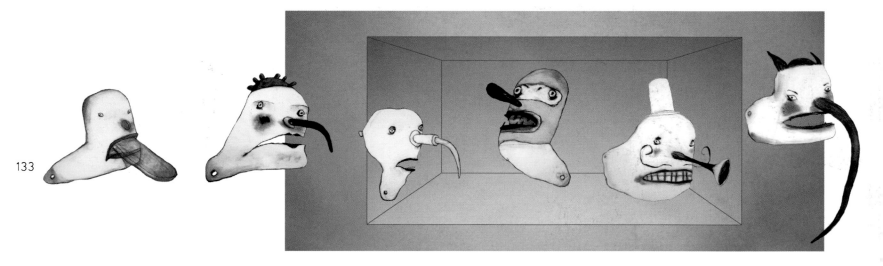

BELOW/LEFT/AD-MAN FOR THE MORAL CIRCUS
BELOW/RIGHT/CONSUMER FOR THE MORAL CIRCUS

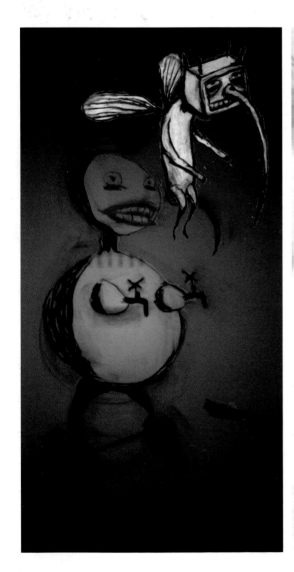

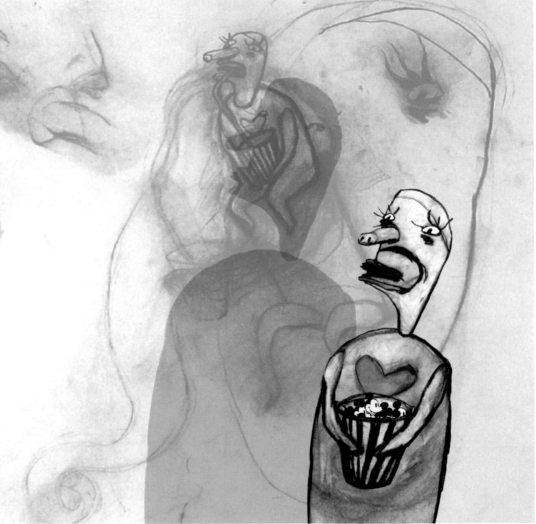

134

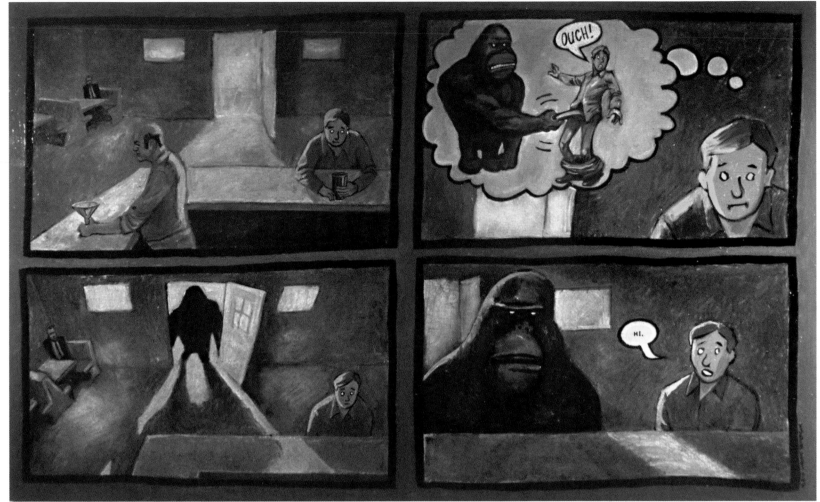

135

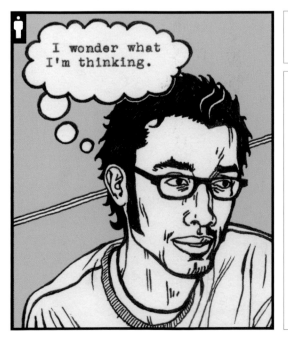

ERIK PATTERSON

"I FIND TRUE RANDOMNESS INSPIRING", DECLARES AMERICAN FINE ARTIST AND ILLUSTRATOR ERIK PATTERSON. "THERE ARE MORE THINGS AROUND US THAN WE'D LIKE TO REALIZE WHICH MAKE ABSOLUTELY NO SENSE AT ALL." WORKING IN VARIOUS MEDIA INCLUDING OIL AND ENAMEL PAINT OR SOMETIMES PEN AND INK, BROOKLYN-BASED PATTERSON SAYS HIS ART-WORK REFERENCES "POP CULTURE ILLUSTRATION, COMIC BOOKS AND FILM NOIR OF THE MID-TWENTIETH CENTURY, BUT WITH AN EXTRA GLOSS OF FAKENESS OVER IT". HE IS CURRENTLY IN THE PROCESS OF SETTING UP WHAT HE DESCRIBES AS A "NOMADIC" ART GALLERY (THE NEXT EXHIBITION IS BEING HELD IN A BOX TRUCK).

ABOVE/EVIL GORILLA

BELOW/TOP/MR NO AND MR MAYBE
BELOW/BOTTOM/A CAR CRASH OPPOSITE/TOP/THE LAW
OPPOSITE/BOTTOM/MR NO MEETS MISS WHY NOT

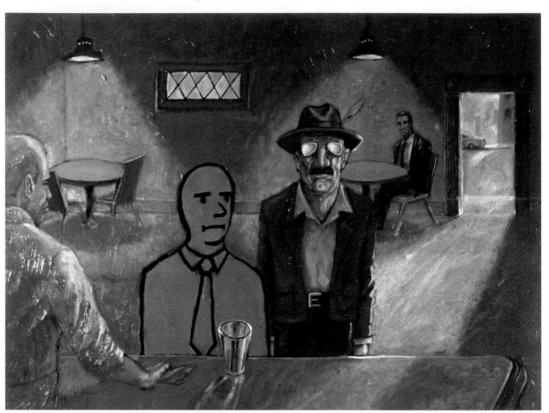

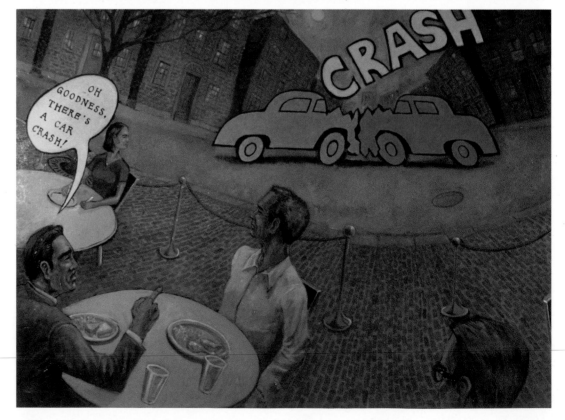

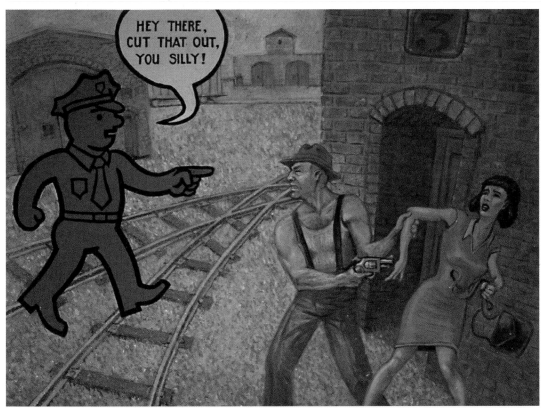

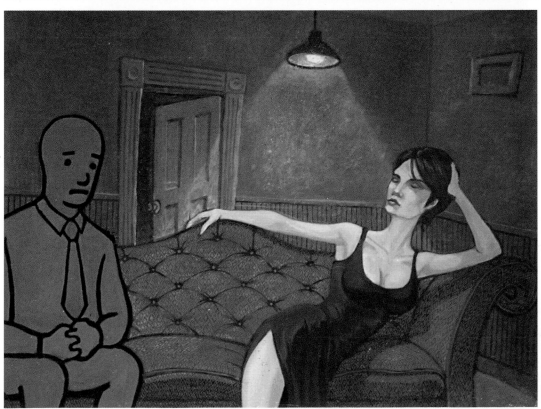

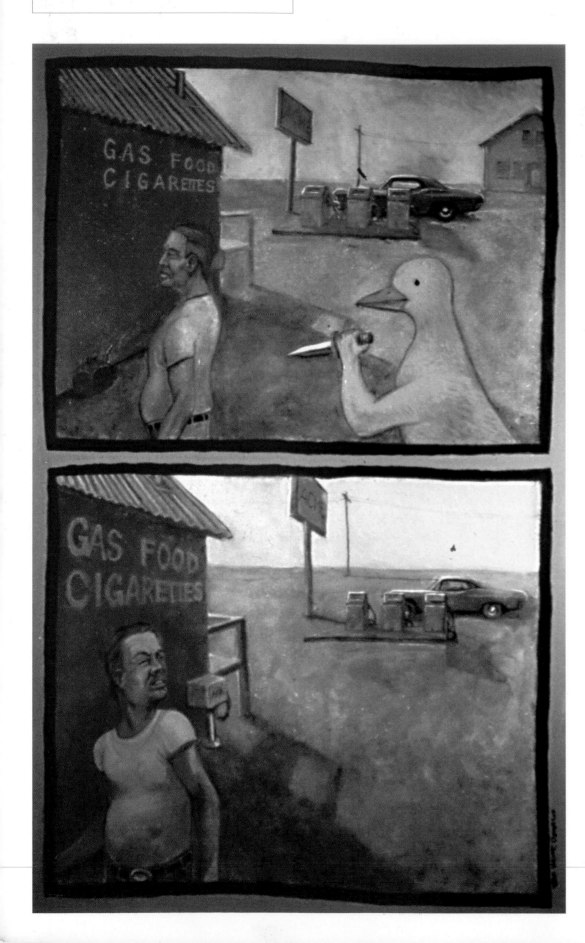

138

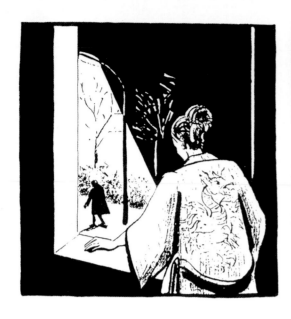
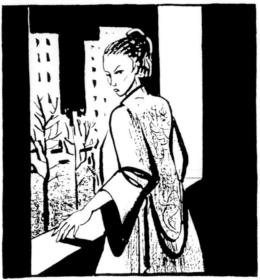
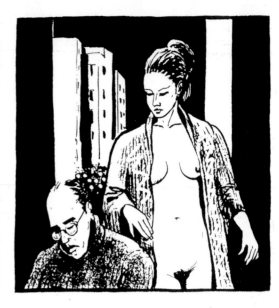

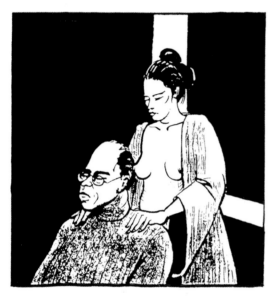
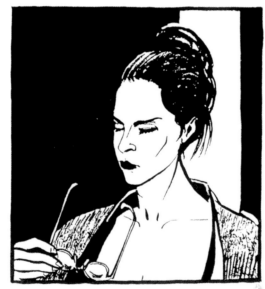
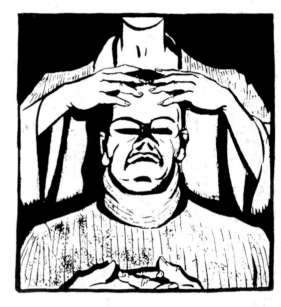

ANDRZEJ KLIMOWSKI

DESIGNER AND ILLUSTRATOR ANDRZEJ KLIMOWSKI WAS BORN IN THE UK OF POLISH PARENTAGE. HE TRAINED AT CENTRAL SAINT MARTINS COLLEGE OF ART AND DESIGN, THEN AT THE ACADEMY OF FINE ART IN WARSAW, WHERE HE ALSO WORKED PROFESSIONALLY. HE IS CURRENTLY HEAD OF ILLUSTRATION AT THE ROYAL COLLEGE OF ART IN LONDON. SINCE THE LATE 1970S, KLIMOWSKI HAS DESIGNED POSTERS AND BOOK JACKETS FOR FABER & FABER AND PENGUIN, AS WELL AS COMPLETING COMMISSIONS IN EDITORIAL DESIGN, TV GRAPHICS AND ANIMATION. HE DEDICATES MUCH OF HIS TIME TO SELF-INITIATED PROJECTS, INCLUDING SHORT FILMS, ILLUSTRATIONS AND BOOKS, MOST RECENTLY THE SECRET, PUBLISHED BY FABER & FABER. HIS WORK, WHICH HAD PREVIOUSLY BEEN LARGELY COLLAGE-BASED, NOW USES GOUACHE PAINT, INK AND LINOCUT. "IN RECENT YEARS I HAVE BECOME AWARE OF THE QUICKENING PACE OF FASHION AND TECHNOLOGY. THE MEDIA WORLD IS EXPANDING AT BREAKNECK SPEED AND WE ARE DROWNING IN AN EXCESS OF INFORMATION, MUCH OF WHICH IS SLIGHT AND OF NO LASTING VALUE. MY RESPONSE TO THIS EXCESSIVE OUTPUT IS TO SIMPLIFY MY WORKING METHODS."

ABOVE/THE SECRET

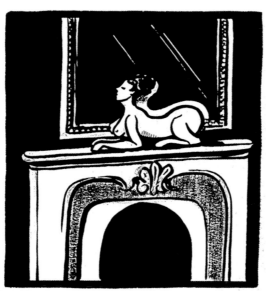
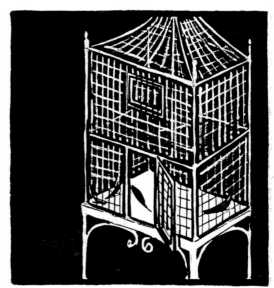
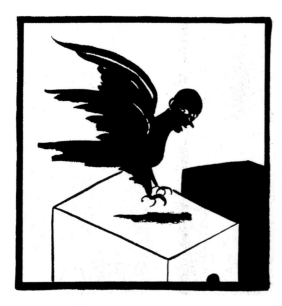
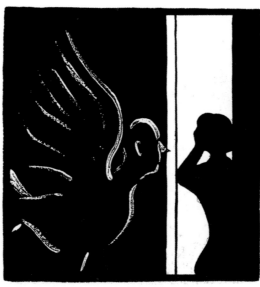
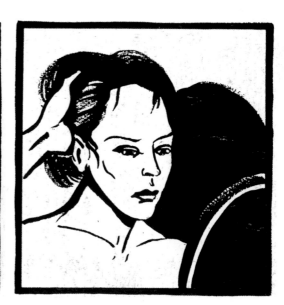

CHRISTINE BERRIE / www.christineberrie.co.uk

MICHELLE THOMPSON / michellethompson.studio@btinternet.com

KERRIE JANE STRITTON / kerrie@kerriestritton.co.uk

LUCINDA ROGERS / lucindadot@hotmail.com

LAURA LEES / lauraleeshq@hotmail.com

OLIVIER KUGLER / ol_kugler@hotmail.com

DELTA / dlt@deltainc.nl

DAVID FOLDVARI / david.foldvari@sukie.co.uk C/O greg@bigactive.com

RICHARD BEACHAM / 07771 963 980 / 01452 503 243

MARION LEFEBVRE / sugargrafiks@hotmail.com

BERNIE REID / bern.beca@btinternet.com

ISABEL BOSTWICK / bee_trevelyan@hotmail.com

FRAUKE STEGMANN C/O Natalie Bertaux/Maisonette 020 7482 5935

MODE 2 / mode2@mode2.org

LAURENT FÉTIS / fetis.laurent@wanadoo.fr

NINA CHAKRABARTI / nina.chakrabarti@rca.ac.uk

DEANNE CHEUK / Neomuworld@aol.com

MAJA STEN / maja_sten@hotmail.com / www.maja–sten.se

KENJI CHO / tam0001@msh.biglobe.ne.jp

JO RATCLIFFE / Jocandraw@aol.com

EDWINA WHITE / fiftytwopickup@hotmail.com

JULIE VERHOEVEN C/O thu@clmuk.com

MARIE O'CONNOR / marie_oconnor8@yahoo.co.uk

MATT DUCKETT / mattduckstar@hotmail.com

LOVISA BURFITT / lovisa@burfitt.com C/O ebba@agentform.se

IZZIE KLINGELS / izzie@zoom.co.uk

OTTO / otto@ottoillustration.com

SEB JARNOT / contact@sebjarnot.com

LUCY MCLAUCHLAN / lucy@beat13.co.uk

LIZZIE FINN / lizzie@lizziefinn.com

BILLIE JEAN / billiejean.is@virgin.net

PATRICK THOMAS / patrick@lavistadesign.com

AUDE VAN RYN / C/O www.heartagency.com

RINZEN / rilla@rinzen.com

AIRSIDE / nat@airside.co.uk

CHRISTOPH NIEMANN / mail@christophniemann.com / www.christophniemann.com

JAMES GRAHAM / jamesgraham2me@yahoo.co.uk / www.jamjot.co.uk

TOM GAULD / tgauld@hotmail.com / www.cabanonpress.com

SIMONE LIA / s.lia@virgin.net / www.cabanonpress.com

GARY TAXALI / gary@garytaxali.com

PETER ARKLE / sparkle@mindspring.com

SARA FANELLI / Flat 11, Howitt Close, Howitt Road, London NW3 4LX, UK / +44 (0)20 7483 2544

CHIU KWONG MAN / man_chiu_kwong@hotmail.com

ERIK PATTERSON / erikwp333@hotmail.com

ANDRZEJ KLIMOWSKI / 105 Sutton Court, London W4 3EE, UK / +44 (0)20 8994 1940

LAURENCE KING

Published in 2003 by Laurence King Publishing Ltd
71 Great Russell Street
London WC1B 3BP
United Kingdom
Tel: +44 20 7430 8850
Fax: +44 20 7430 8880
e-mail: enquiries@laurenceking.co.uk
www.laurenceking.co.uk

144

A catalogue record for this book is available from the British Library

ISBN-13: 978 1 85669 339 4
ISBN-10: 1 85669 339 2

Printed in China

Editor/Art Director: Angus Hyland, Pentagram Design
Editor/Introduction: Roanne Bell
Designer: Sharon Hwang, Pentagram Design
Cover Illustrations: Marion Deuchars

Thank you to Will Irvine, Patrick Burgoyne, Paula Carson, Nathan Gale, Gavin Lucas, Mark Sinclair,
Helen Walters and all at Creative Review, Rick Poynor, Darrel Rees, Greg Burne, Ebba Kettner,
Amanda Mason, Thu Nguyen and everyone who has contributed to this book.